MAMIKA

MY MIGHTY LITTLE GRANDMOTHER

Sacha Goldberger

W9-CDG-024

HARPER
DESIGN

An Imprint of HarperCollinsPublishers

MAMIKA: MY MIGHTY LITTLE GRANDMOTHER
Copyright © 2012 Sacha Goldberger

Originally published as *MAMIKA: Grande petite grand-mère* © by Balland Éditeur, 2010.

HarperCollins books may be purchased for educational, business, or sales promotional use. For information please write: Special Markets Department, HarperCollins*Publishers*, 10 East 53rd Street, New York, NY 10022.

First published in 2012 by
Harper Design
An Imprint of HarperCollins*Publishers*
10 East 53rd Street
New York, NY 10022
Tel: (212) 207-7000
Fax: (212) 207-7654
harperdesign@harpercollins.com
www.harpercollins.com

Distributed throughout the world by
HarperCollins*Publishers*
10 East 53rd Street
New York, NY 10022
Fax: (212) 207-7654

Library of Congress Control Number: 2011931358

ISBN 978-0-06-210788-6

Book jacket design and typesetting by: Agnieszka Stachowicz

Printed in China

First Printing, 2012

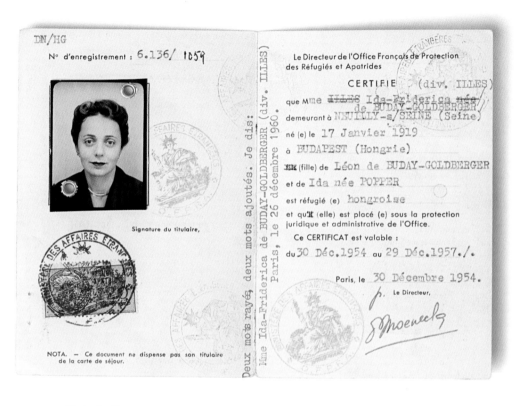

This is the most beautiful project I have ever worked on.
A book celebrating the grandmother of my life.
I love you, Mamika; I adore you even. Forever.

(LET'S BE CLEAR: I WILL NOT LEND MY GRANDMOTHER TO ANYONE
FOR ANYTHING IN THE WORLD. EVEN FOR FIVE MINUTES.
I AM SELFISHLY KEEPING HER FOR MYSELF.)

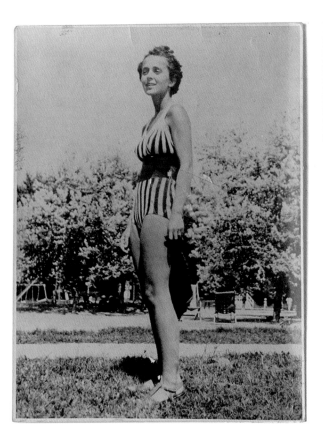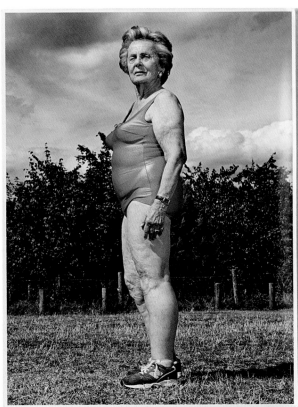

I cannot begin talking about this project without first telling you about the wonderful figure of Frederika, the subject of this book. Frederika is ninety-three years old and was born in Budapest twenty years before the war. A Jew from Central Europe and a baroness, she comes from a very wealthy and respected family. She saved ten people during the war, risking her life to do so. Frederika survived both Nazism and Communism. She immigrated to France after the war, her family in tow, forced by the Communist regime to leave her country clandestinely under penalty of death.

Other than great strength of character, it is humor that characterizes her. Humor that defies adversity and time. Frederika is funny and cynical—she takes every possible opportunity to wisecrack; she makes as much fun of the people she loves as she does of herself.

In Hungarian, *mamika* means "my little grandma." The term is tender and affectionate, just like this book's character. First and foremost, this book tells a great love story between a grandmother, who is a bit of a ham, and her photographer grandson. More than three years went into making this series of photographs, which is becoming more and more valuable as the weeks go by.

Mamika deals with a number of increasingly relevant social issues: aging, loneliness, senility, humor, quirkiness, love, and above all, hope.

For me, the primary value of these images lies in the fact that they restored to their model (my grandmother) the feeling of being useful, the pride, and above all the joie de vivre that she had lost in the previous few years.

After working until the age of eighty, Frederika left the spotlight and found herself retired, alone with herself and her imposed solitude. She was depressed, and in December 2006, I decided—with her consent—to take a series of photographs of her, in which she would be presenting both my books and a few products derived from them for a future website. Who better than she, who was so close to me, to present my work?

I have to confess that, at first, my grandmother was not very enthusiastic. The main reason she posed was to do me a favor and spend some time with me. The first photos were not very good: ill-at-ease, a touch removed, she forced herself to smile.

After a few days together, humor—her humor, our humor, the one she is still handing down to me and that brings us together so much—that humor took over. She started playing and posing with enthusiasm.

I woke up the next day with an idea in mind. My grandmother was not to simply present my creations; I was to set the stage for her, to exploit her talents as a comedienne. We went to her office. She put on one of my T-shirts and then sat down. I fetched a can of hair spray. "Can you make a phone call with this can?" I asked. "Of courrrssse!" she replied in her trademark cute little accent. She took the can, stuck it against her ear, and very naturally started speaking: "Hallo, Margitte? It's Frederika heeerrre, helllooo!" Right in front of my eyes was precisely the image I had imagined during the night.

I started shooting. "Perhaps I could do something with your motorcycle glasses," she suggested. She put on my helmet. I placed her in front of the lens. She held at chest level one of my little heart-shaped boxes with *"tu es ici"* (you are here) written on it, then took a pose I did not expect.

"Don't move!"

"I knew you would like it," she said to me, smiling.

The book was born. We haven't stopped taking pictures since. It turns out that, through the process of making photographs, my grandmother has become a real professional, who acts, who lets herself be directed, but who also contributes expressions.

After posting this series on Myspace, I had to acknowledge its unexpected success. I decided to create a page dedicated to my grandmother, with her photographs, her story, her friends. Today she has more than two thousand friends and has received an incredible number of e-mails. "You are the grandmother I always dreamed of—will you adopt me?"; "You brightened my day"; "I hope I'm like you when I am your age"—such are some of the messages on her page. She regularly replies to these messages from her Mac.

At the beginning, she didn't understand why all these people were writing to her, congratulating her. Then, little by little, she came to understand that she was bringing joy and a message of hope through all these photographs.

Quirkiness and humor are this book's main thread. You have to be able to make fun of everything, including yourself. I've tried to show that you can still have fun in life in your nineties.

In a society where youth is the supreme value; where wrinkles have to be camouflaged; where old people are hidden as soon as they become cumbersome; where, for lack of time or desire, it is easier to put our elders in hospices rather than take care of them; I wanted to show that happiness in aging was also possible, even if some pictures leave you wondering whether they come closer to senility than to humor. Sometimes that line is a very fine one.

But she's been much better since that experience. She came out of her depression, perhaps because she feels she is being useful and because her virtual friends are a daily reminder that she is still alive.

"It's been a while since we last took photos," my little grandma tells me frequently. "Don't you have any new ideas?"

—Sacha Goldberger

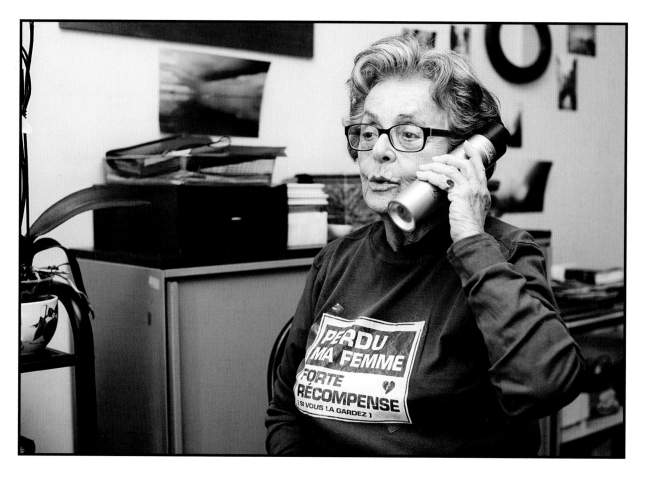

MAMIKA'S SHIRT READS:
LOST
MY WIFE
LARGE REWARD
(IF YOU KEEP HER)

the helmet.

THIS ONE IS MY FAVORITE

BECAUSE THIS HELMET SUITS ME VERY WELL, AND IT IS
VERY BEAUTIFUL WITH THE STAR AND THE GOGGLES.
WHAT I DON'T LIKE ARE THE ROLLS ON MY STOMACH.
A REAL PHOTOGRAPHER WOULD HAVE REMOVED THESE
ROLLS FOR ME. THESE ROLLS THERE.

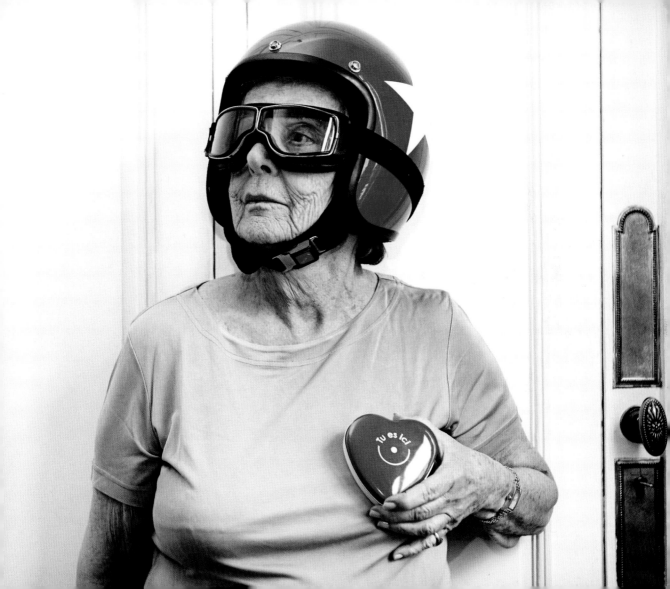

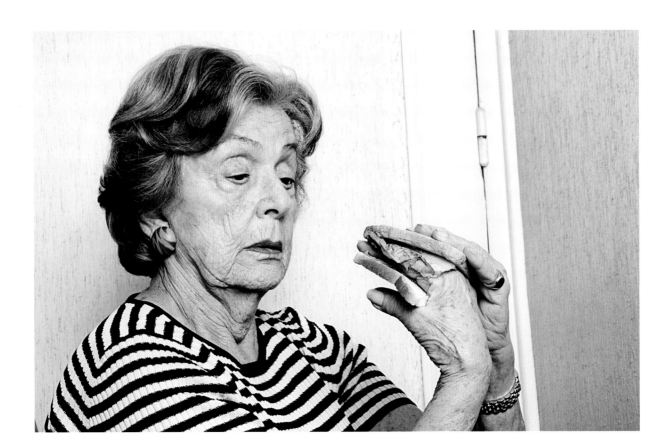

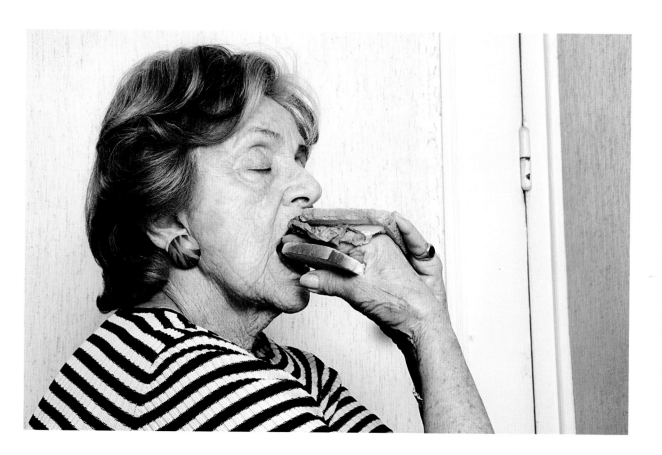

SEE WHAT CAN HAPPEN WHEN YOU EAT **TOO ORGANIC?**

THE GHERKIN

THIS TRULY IS A VEGETABLE WITHOUT NATIONALITY.

(TO BE SAID WITH A HUNGARIAN ACCENT.)

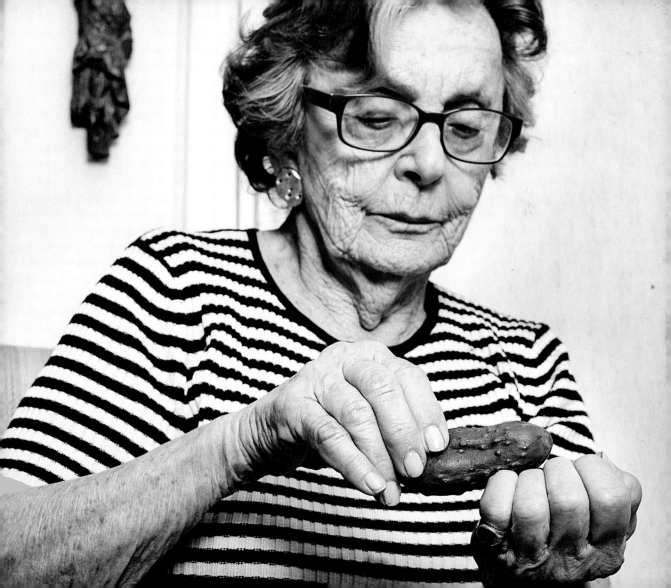

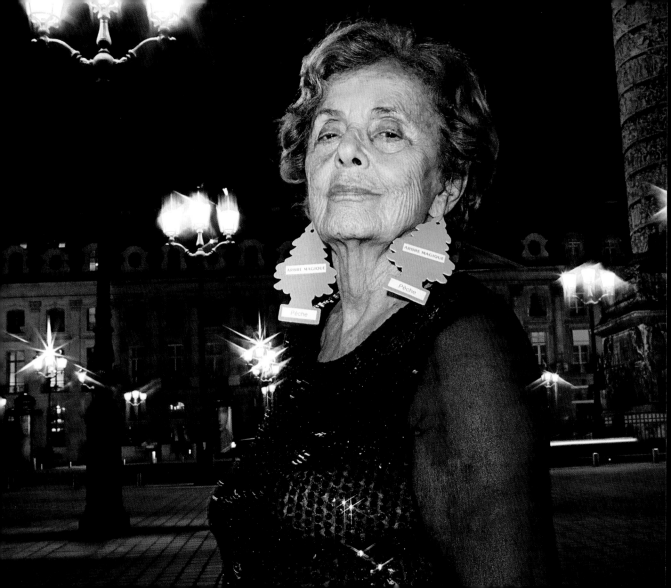

ON THAT DAY,
THE ENTIRE
PLACE VENDÔME
SMELLED LIKE **PEACHES.**

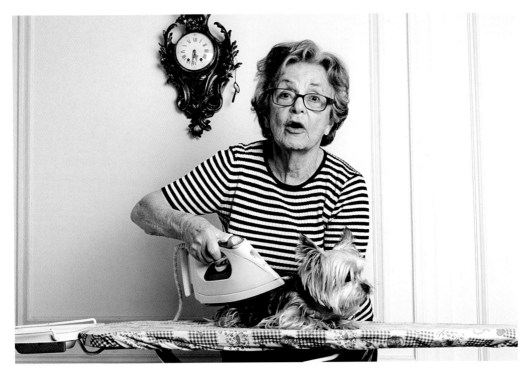

WHEN WE TOOK THIS PICTURE, THE DOG WAS **SHAKING, SHAKING.**
I HAD NEVER IRONED A GARMENT THAT **SHOOK** SO MUCH.
IT TRULY IS PRETTY UNPRACTICAL.

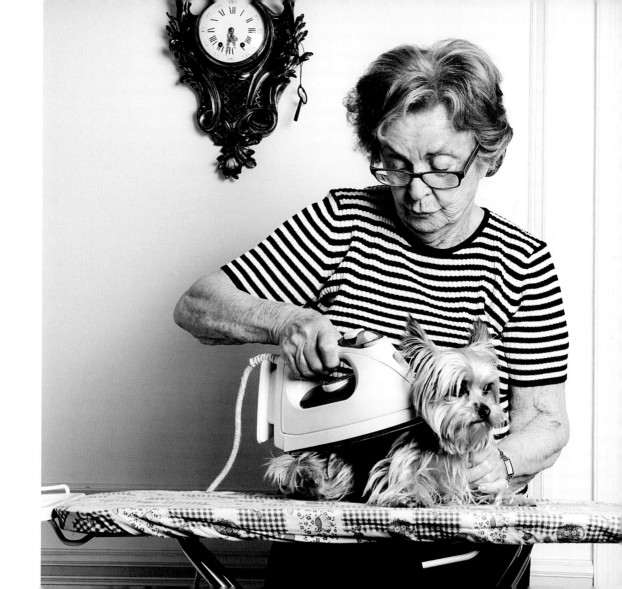

I THINK THE FIRST TIME I RODE A MOTORCYCLE I WAS
EIGHTY-SEVEN YEARS OLD. THE TRUTH IS
I WASN'T EVEN AFRAID. ON THE OTHER HAND,
WE WERE GOING MORE SLOWLY THAN PEDESTRIANS.

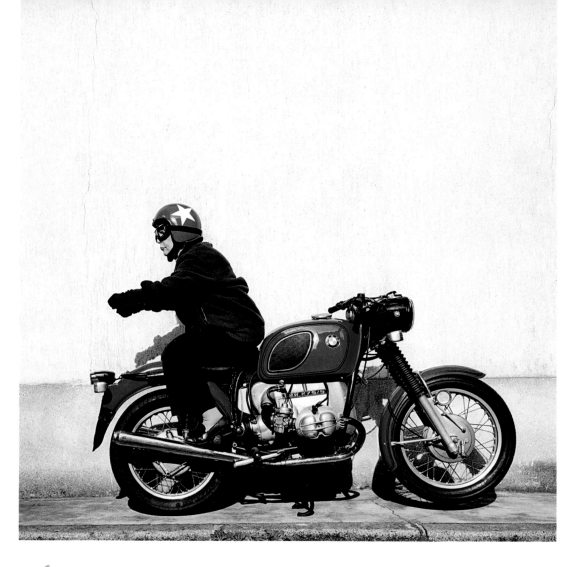

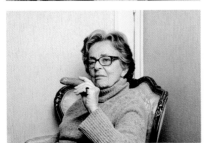
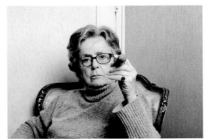
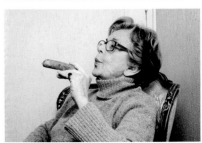
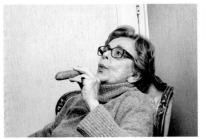
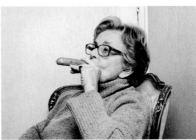

YOU SEE,
SMOKING
REALLY DOES
GIVE YOU
A CERTAIN
CLASS.

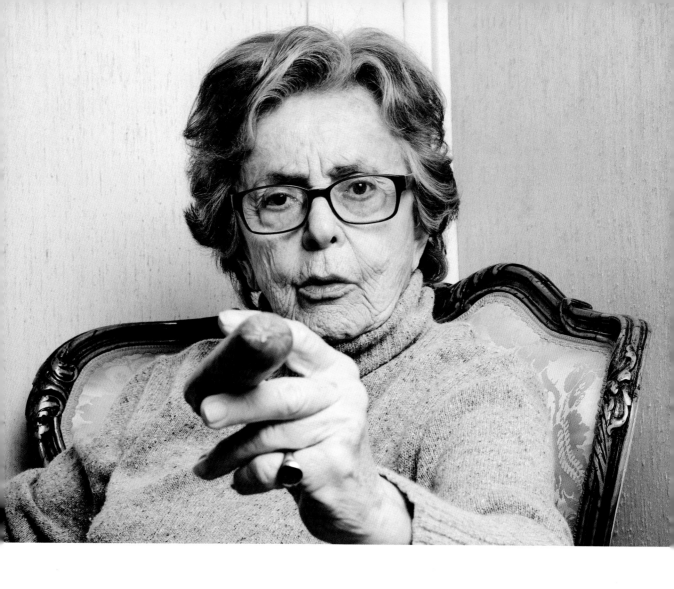

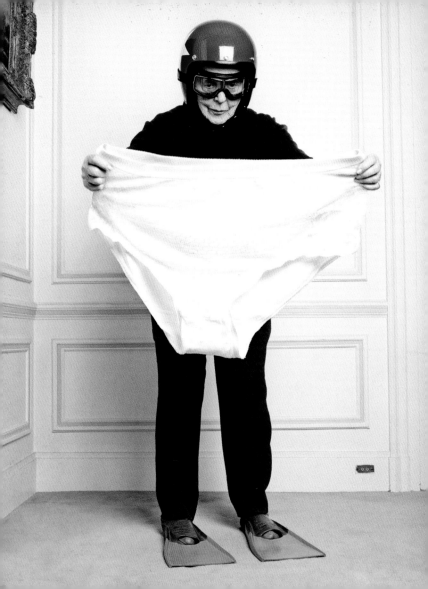

GREAT MINDS
MEET.
GREAT UNDIES:
NOT SO SURE.

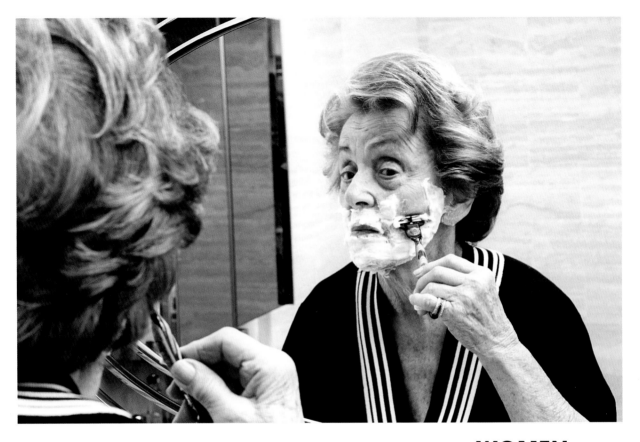

I HAVE ALWAYS BEEN IN FAVOR OF MORE EQUALITY BETWEEN **WOMEN** AND MEN.

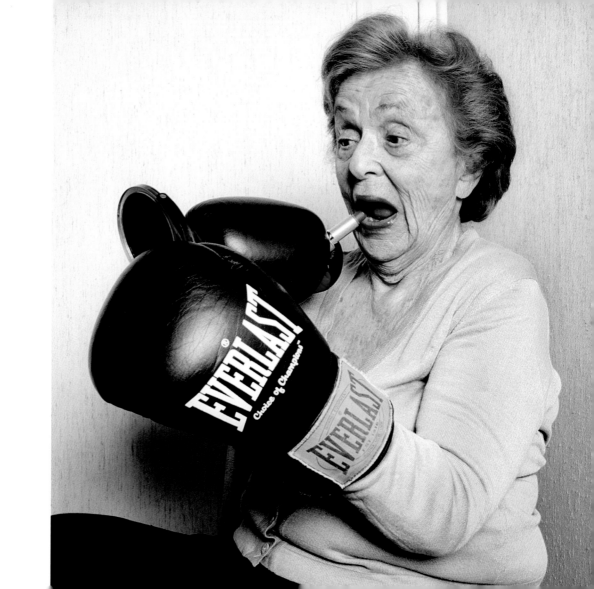

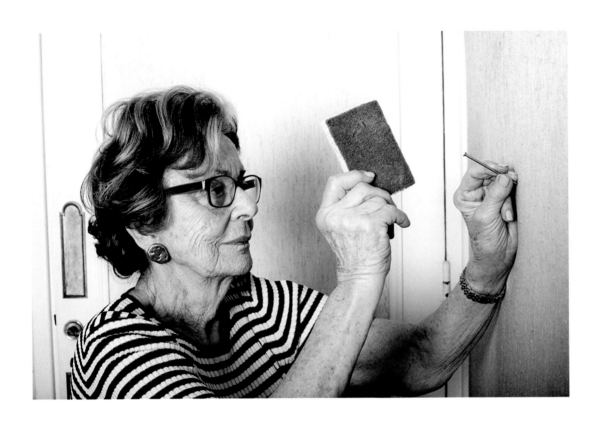

IF YOU MISS THE NAIL, **THE WORST THAT CAN HAPPEN IS YOU'LL GET YOUR FINGER WET.**

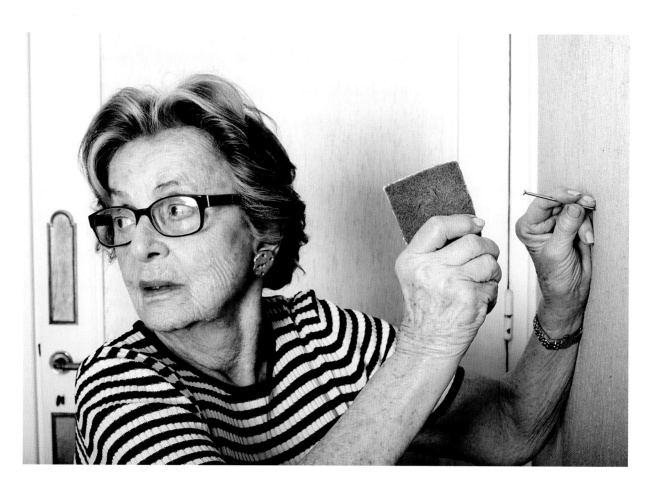

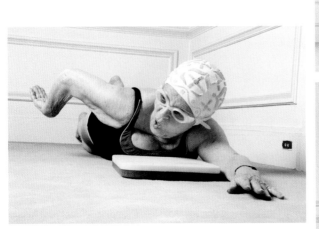
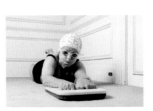
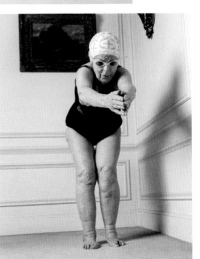
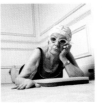

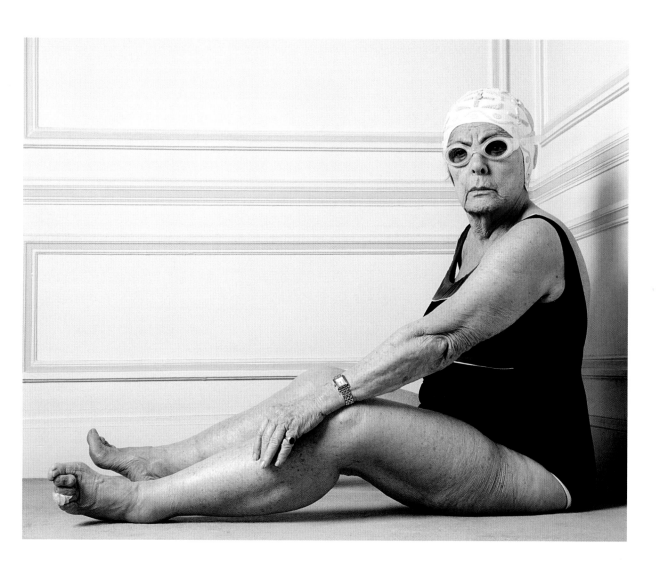

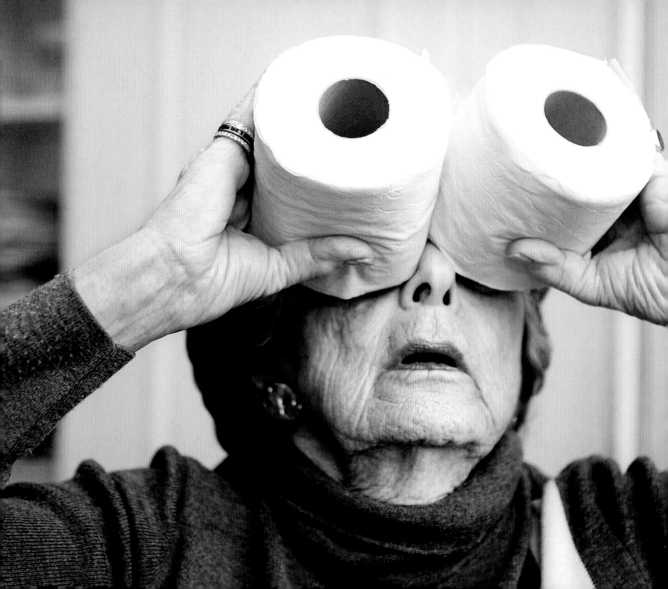

**THIS IS VERY CONVENIENT
IF YOU'RE LOOKING**

FOR SOMEONE WHO'S OFTEN MOONING.

YOU MUST SMOKE CUBANS.

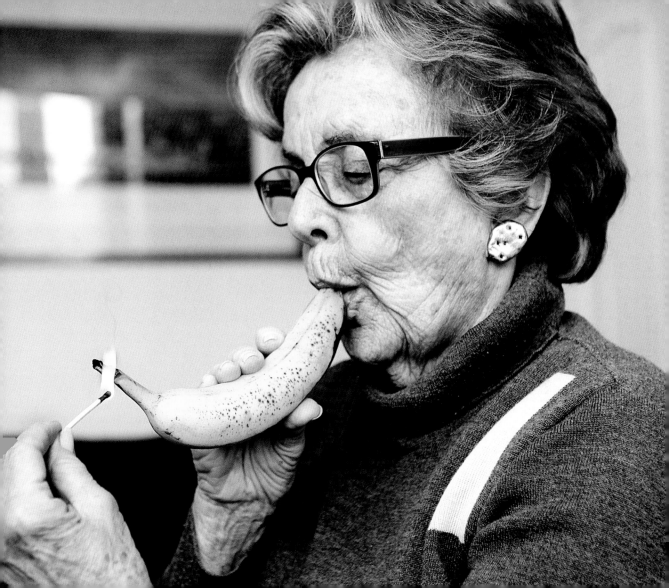

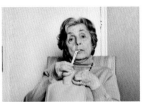
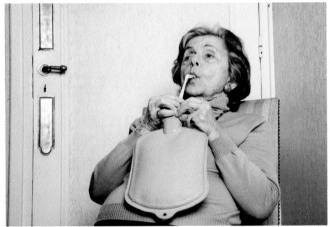
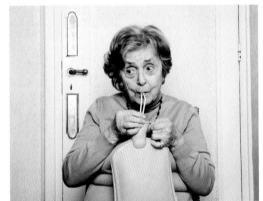

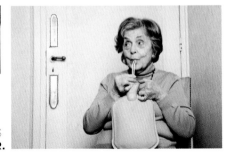

YOU SEE, MY DARLING, DRINKING YOUR TEA WITH A PAIR OF STRAWS
IMMEDIATELY LOOKS **CHICER.**

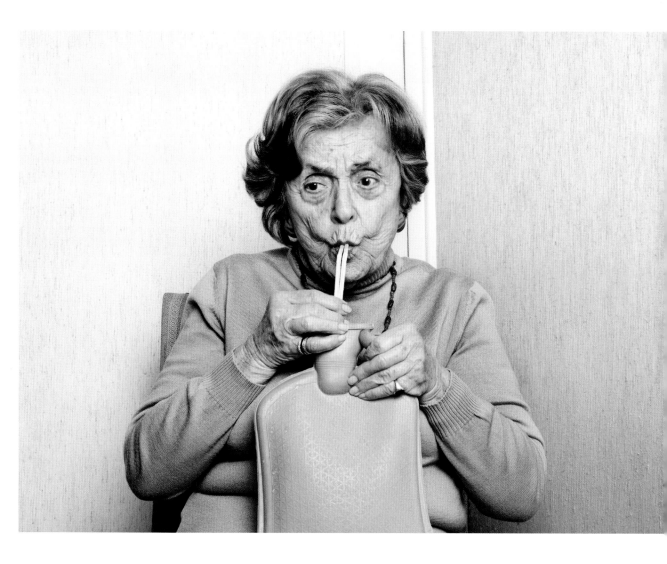

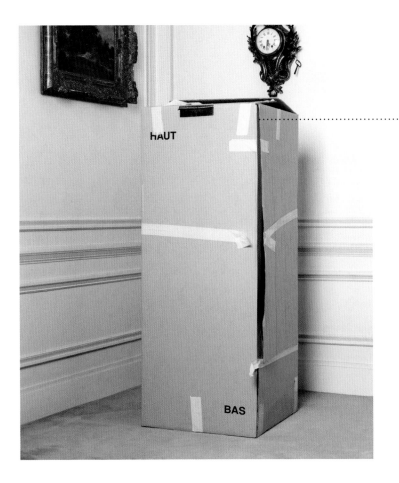

Mamika stepped
into the cardboard
box, suspicious
as always:

"If I go in,
I am going to fall."

"No you won't,"
I replied.

She stepped into
the cardboard box
and shut the door.

One second later,
my assistant and I
were watching
the cardboard box
fall in slow motion.
We caught it just in time.

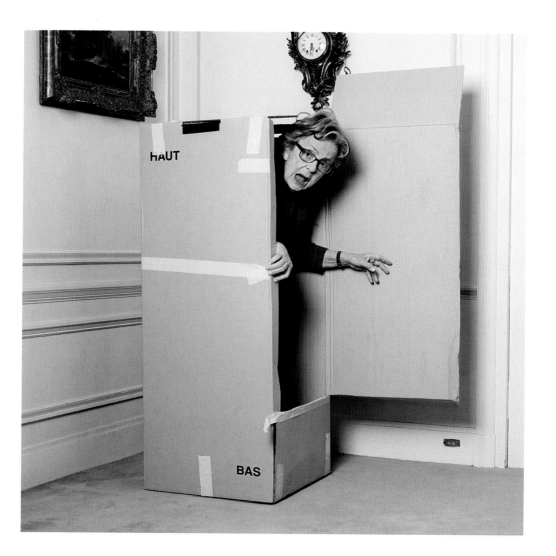

Snail,

HOW-TO.

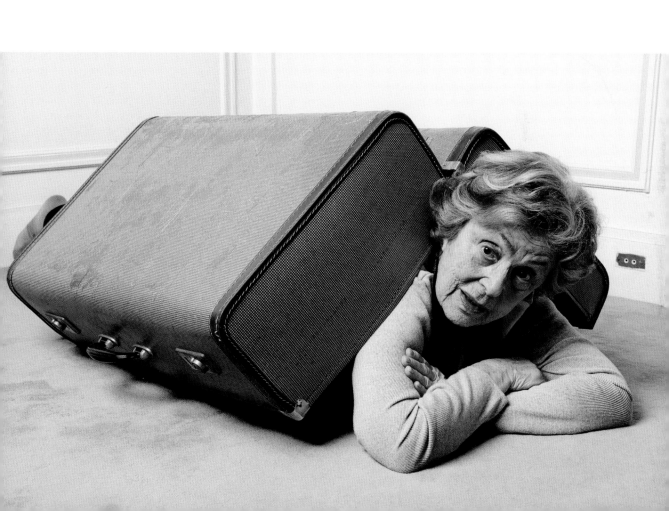

I WAS NEVER REALLY AFRAID OF MICE . . .

EXCEPT PERHAPS WHEN
THEY LOOKED LIKE
ELEPHANTS.

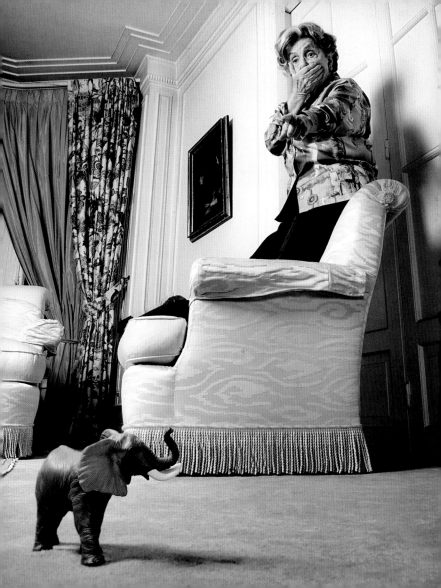

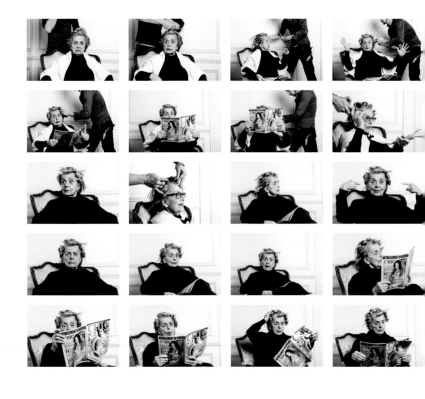

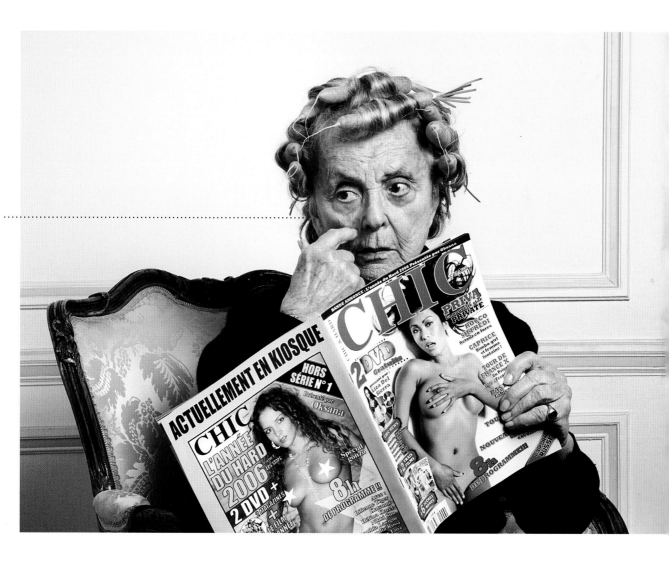

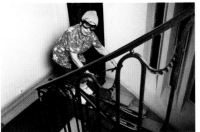

HERE, YOU SEE, THERE'S NO RISK OF AVALANCHE.
(Silence.) **EXCEPT IF I FALL.**

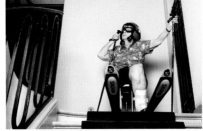

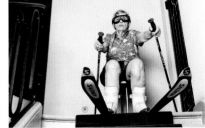

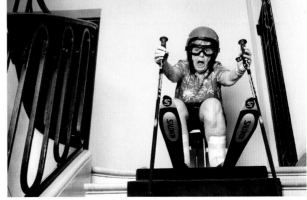

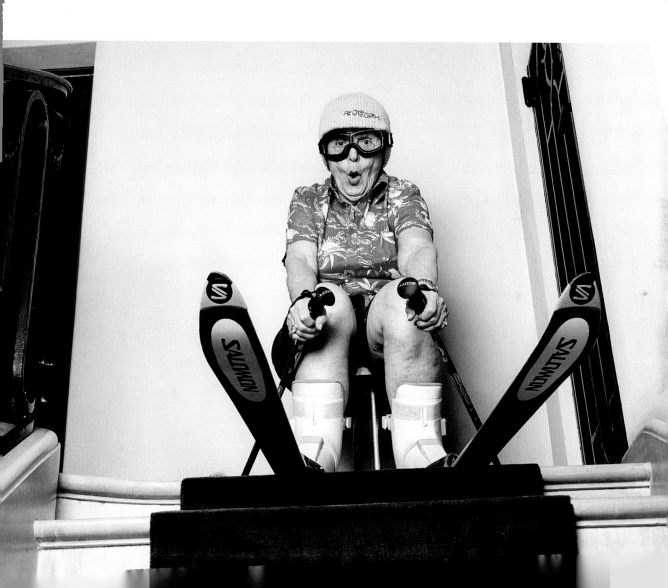

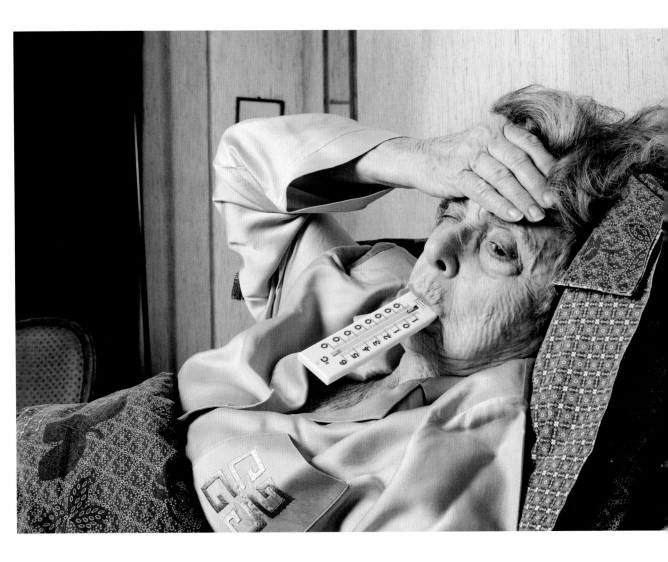

GOOD THING I HAVE A **BIG MOUTH.**
CAN YOU IMAGINE THIS **THERMOMETER** IN SOMEONE'S BUTT?
TEN THOUSAND DISEASES AND WE HAVE ONLY ONE LIFE: **LIFE IS UNFAIR.**

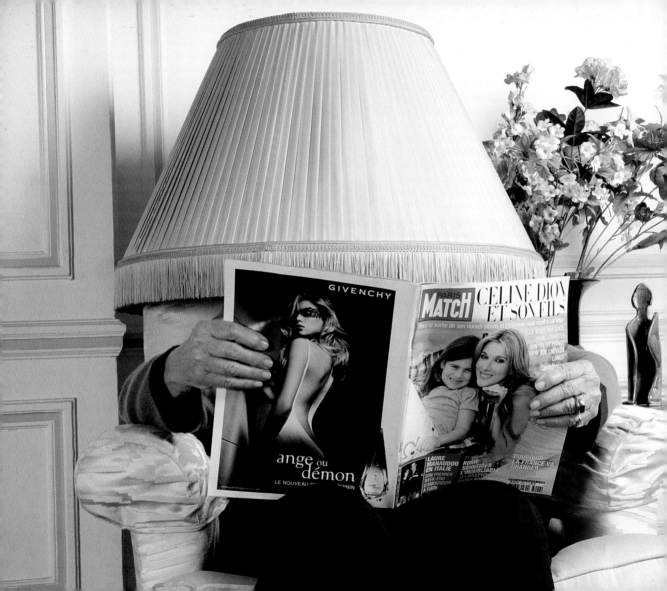

IN HERE AT LEAST IT'S PEACEFUL.

During the entire time the picture was being taken, Mamika was trying to remain serious while all the dogs in the Bois de Boulogne attempted to steal the slice of ham she was holding in her hands. We had to stop the shoot for lack of ham.

ham

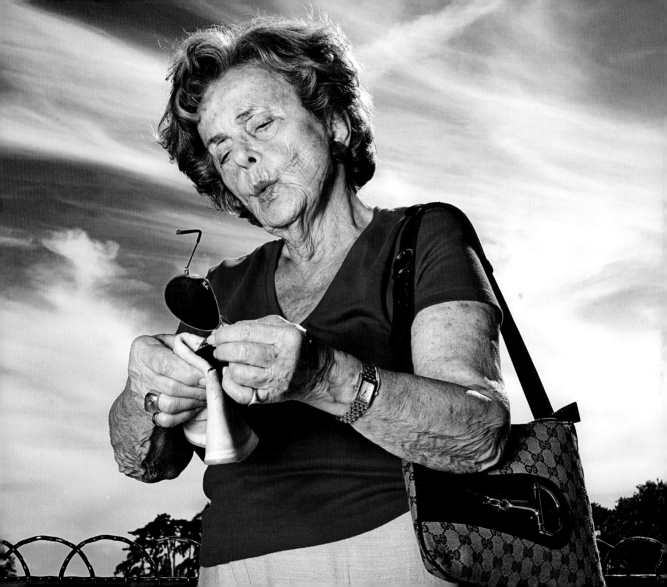

MAMIKA **SACHA**

NO NEED TO We had lunch
TURN ALL afterward.
GREEN I can't remember
WITH ENVY. whether the greens
tasted like clothespins
or not.

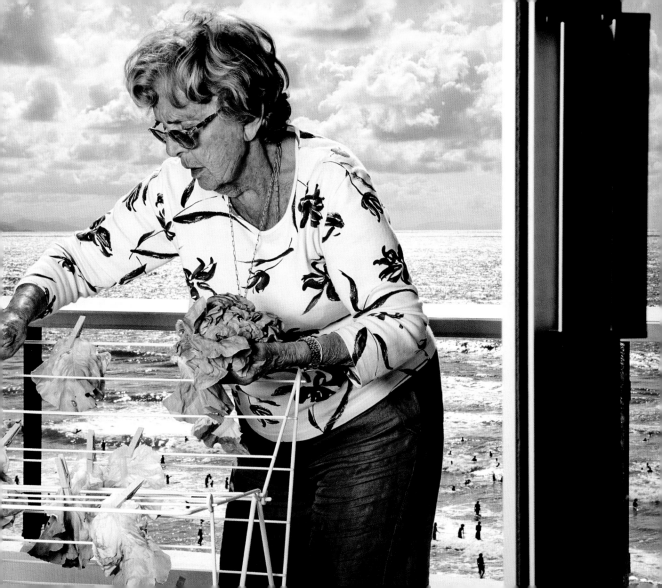

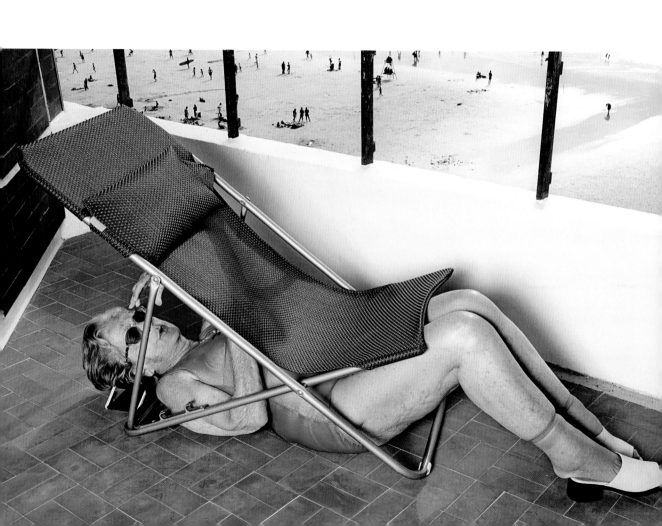

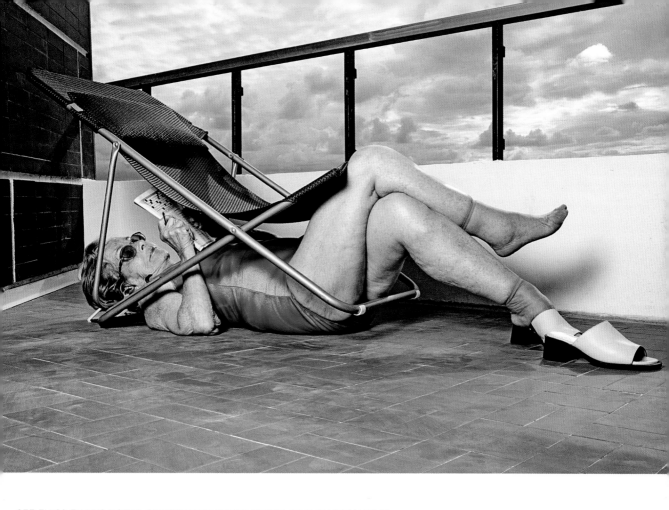

SEE THIS? THAT'S **TOTAL SUNSCREEN** PROTECTION AT THE VERY LEAST.

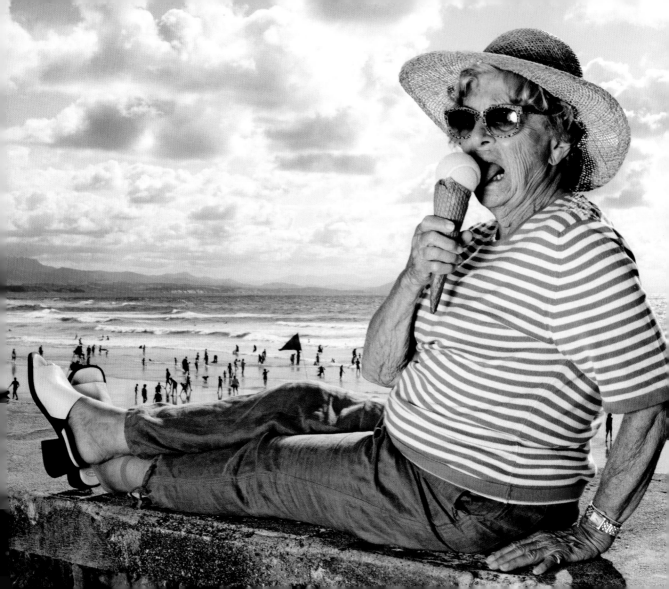

LUCKY FOR ME
YOU DIDN'T HAVE ME LICK
A TENNIS **RACKET.**

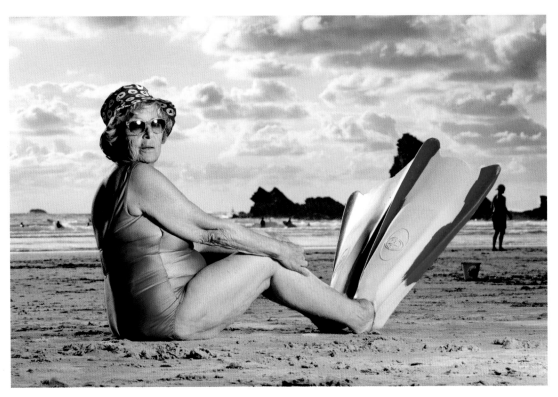

LOOKING LIKE **FLIPPER** THE DOLPHIN'S GRANDMOTHER.

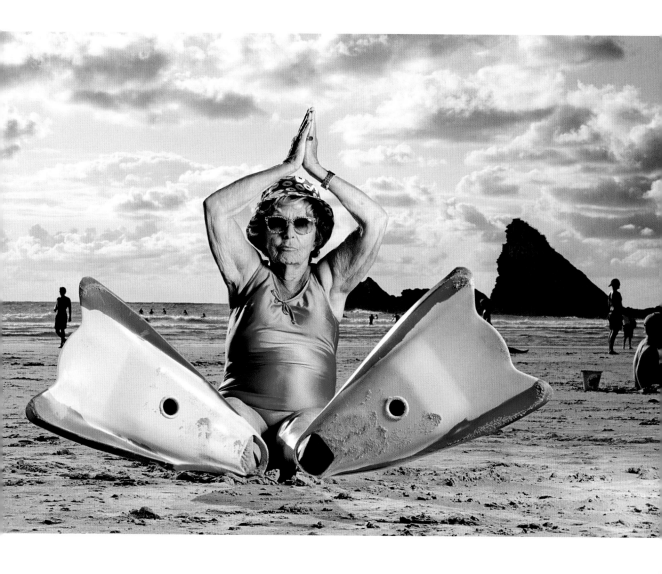

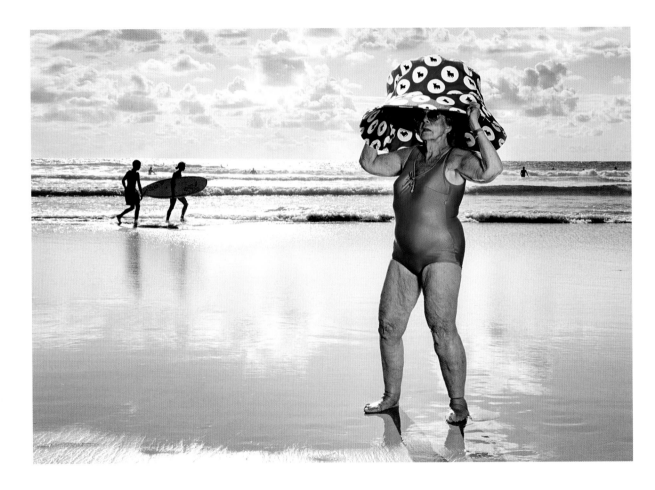

SEE HOW **BIG-HEADED** I'VE BECOME?

This way,

WHATEVER HAPPENS,
YOUR HEAD WON'T SINK.

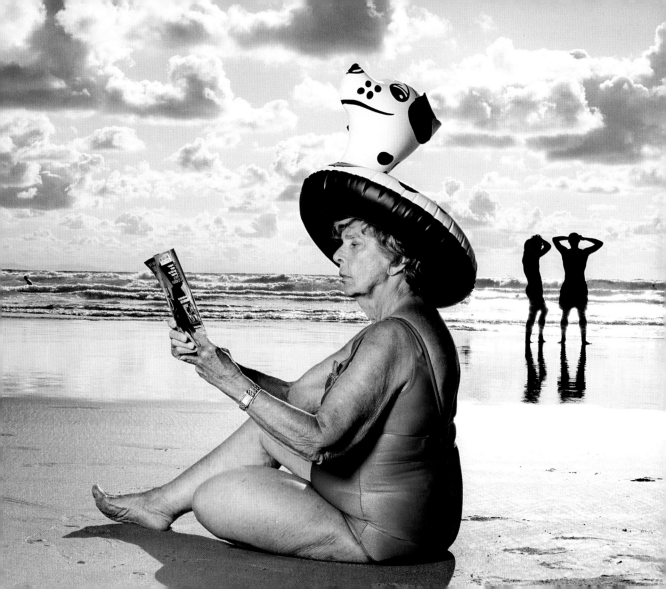

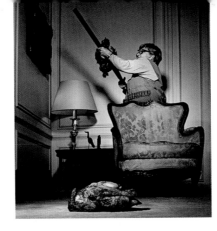

SETUP: 5 minutes

Recipe for
Mamika's Paprika Chicken

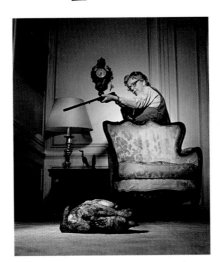

INGREDIENTS
- 2 pairs of guests (with a pinch of humor)
- 1 cordless telephone
- 1 hand
- 1 phone book

PREPARATION
A half-hour before dinnertime, use left hand to hold cordless phone. Open phone book to "Caterers." Next, move right-hand fingers around keypad. Stew for a few seconds. Bring phone to ear and say, "One paprika chicken, please!"

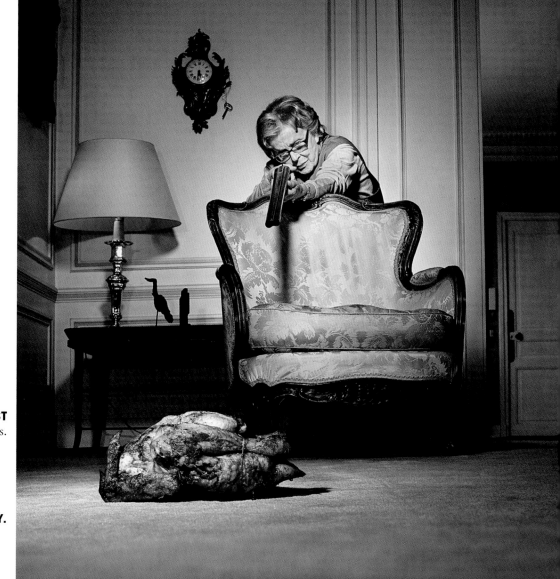

REST
30 minutes.

ENJOY.

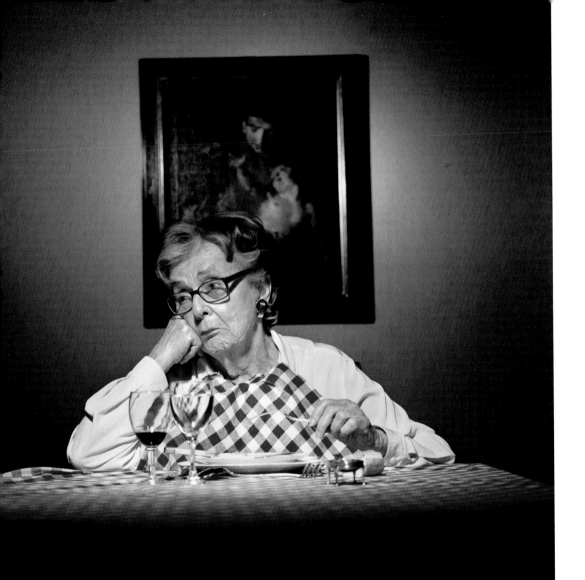

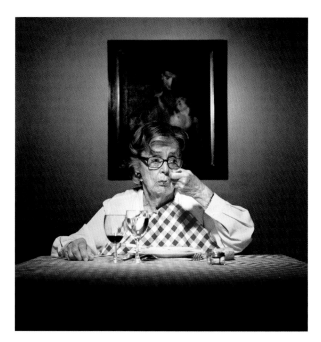 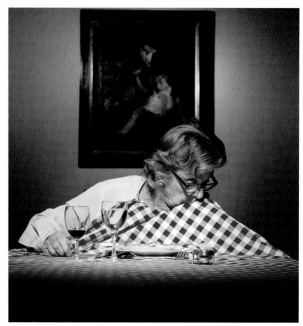

WHAT IS **BRIGITTE BARDOT'S** DRESS
DOING ON THIS TABLE?

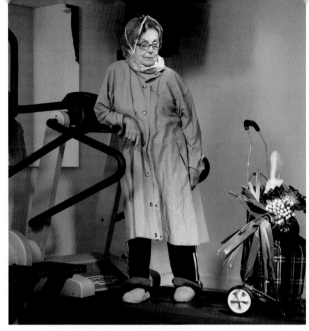

WORKING KEEPS YOU
HEALTHY.
SO DOES GROCERY SHOPPING.

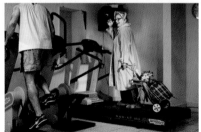

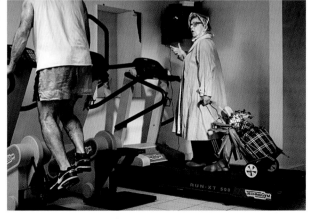

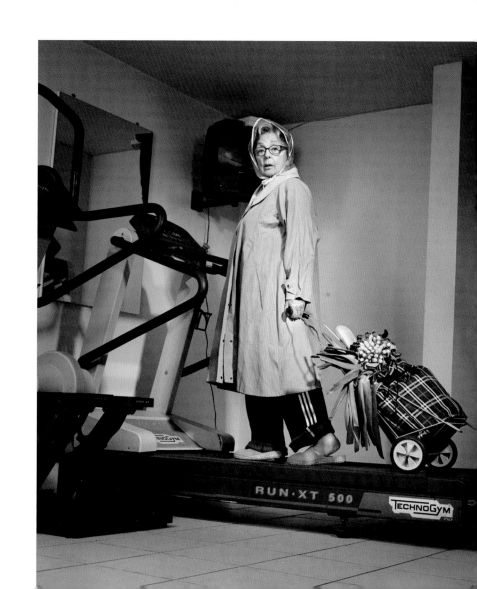

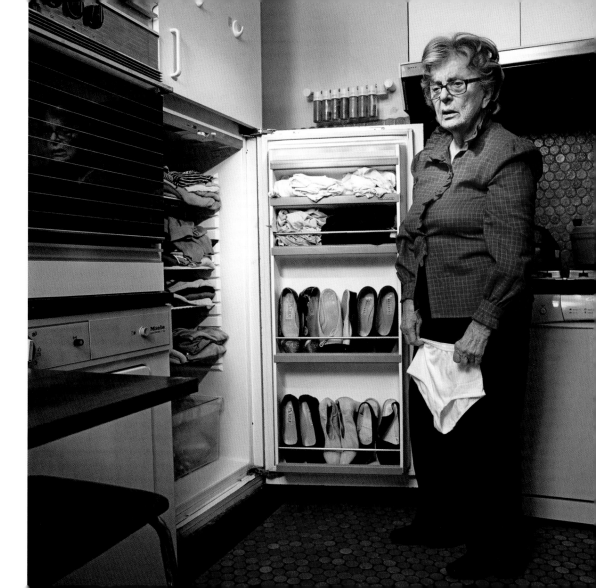

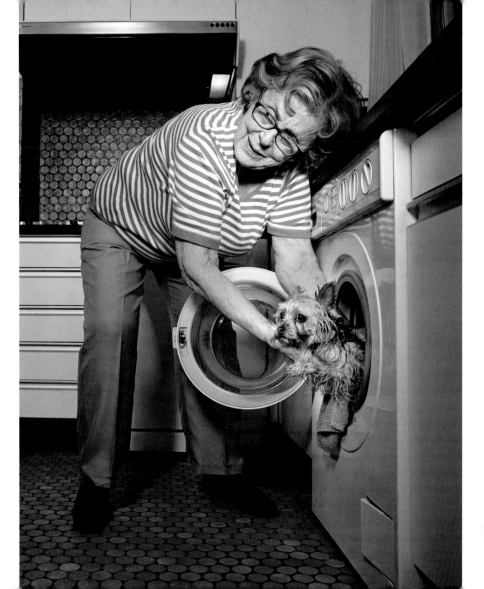

SOMETIMES I LISTEN TO
MY LAUNDRY BARKING.

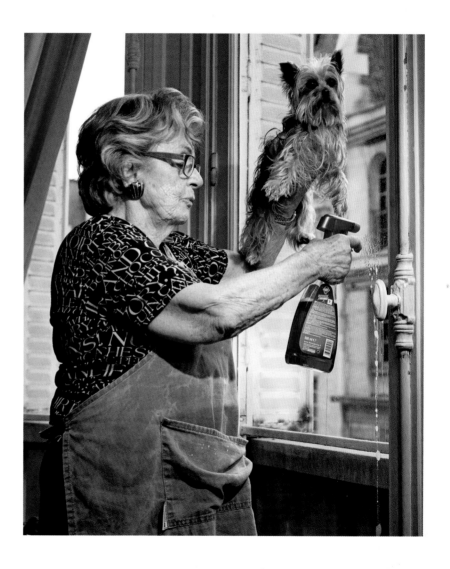

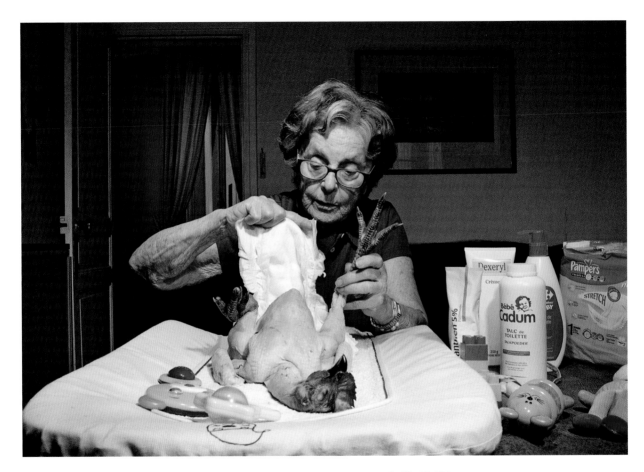

LOOK, HE'S GOT YOUR FATHER'S EYES!

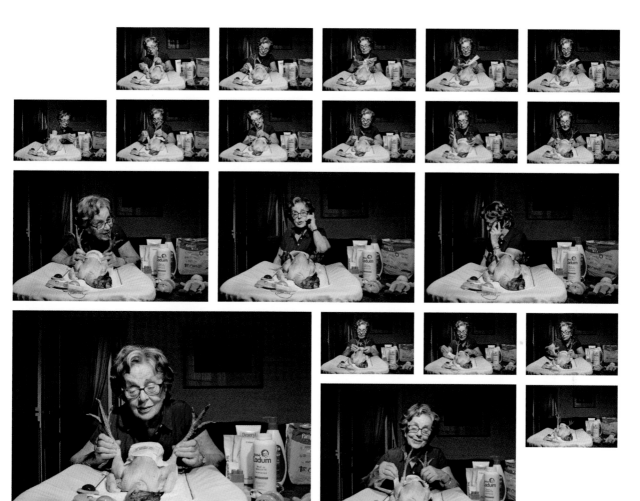

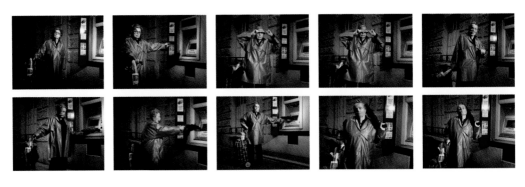

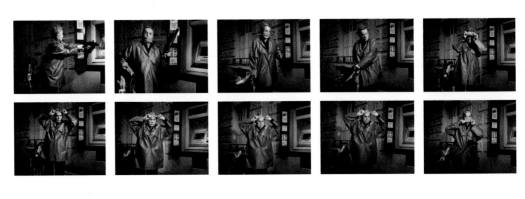

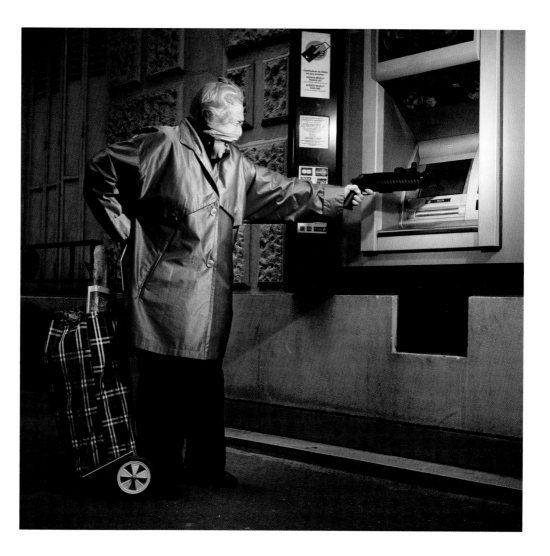

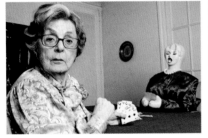

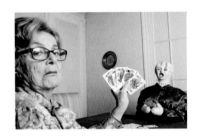

SHE'S NOT VERY TALKATIVE,
WHICH IS WHY SHE'S MY BEST FRIEND.

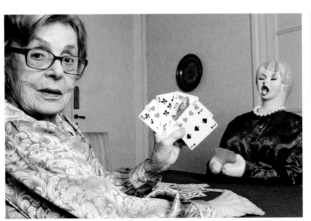

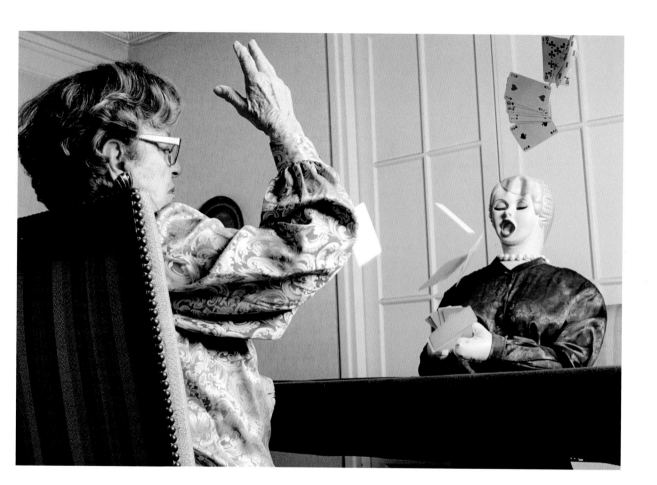

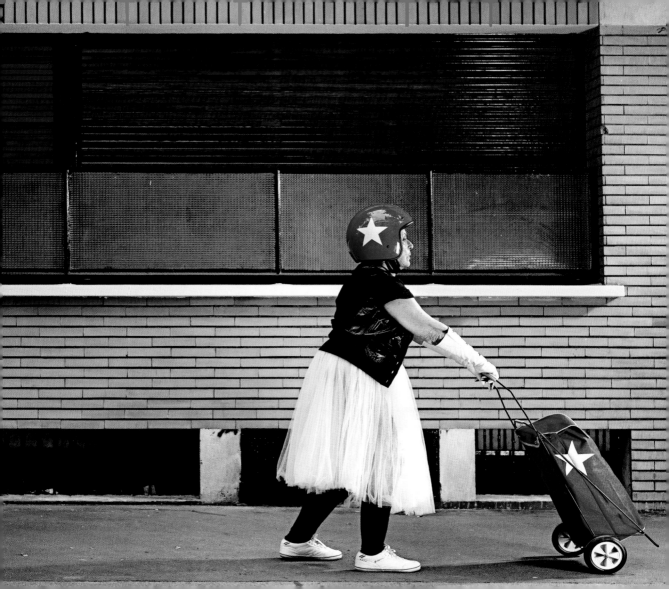

THAT WAY, THERE'S LESS OF A RISK OF CATCHING diseases.

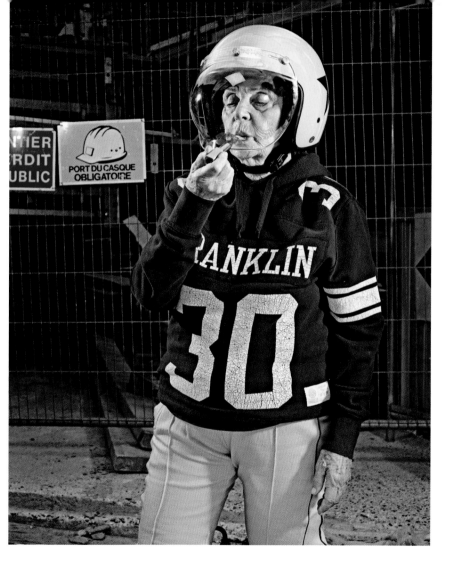

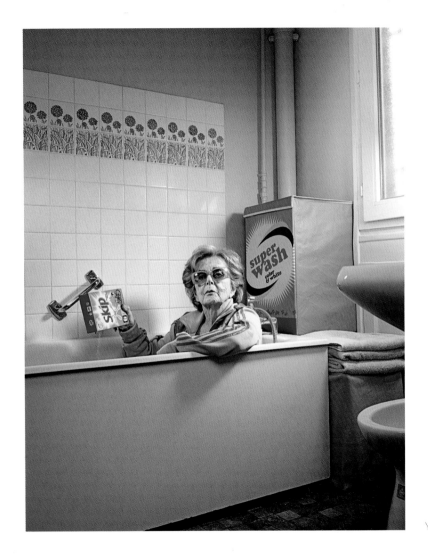

YOU CAN NEVER BE CLEAN **ENOUGH.**

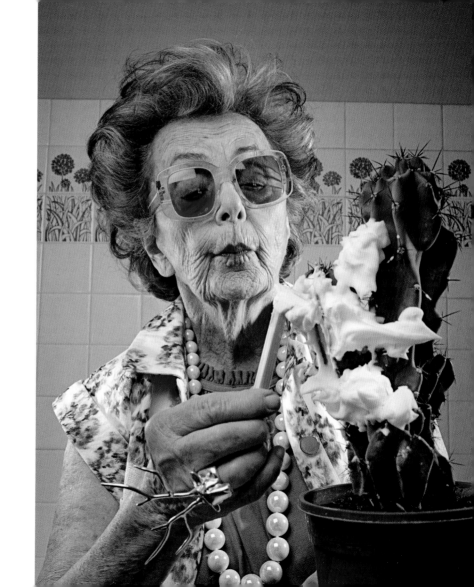

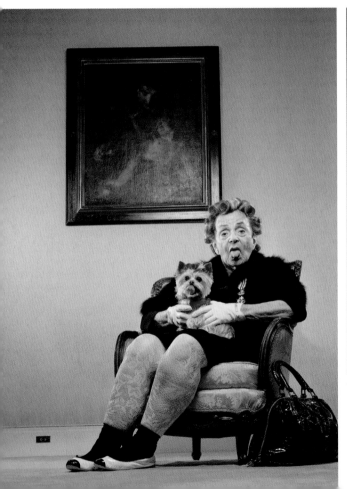

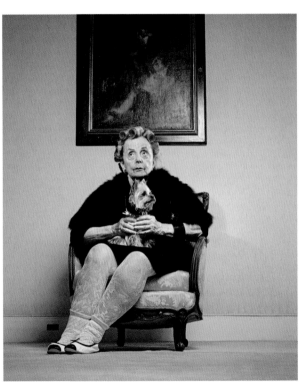

THEY SAY BLACK IS SLIMMING.
LACY WHITE: NOT SO SURE.

EVEN IF YOUR ANKLES ARE SWOLLEN,
WITH BLACK SOCKS
THEY'LL BE SLIMMER.

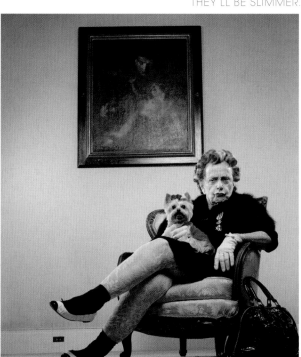

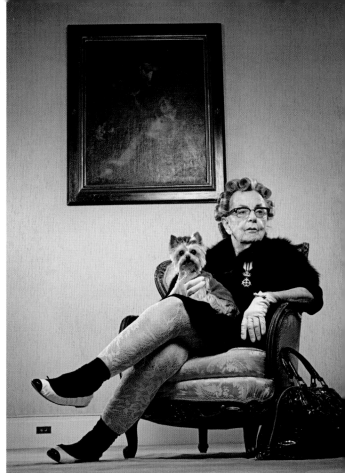

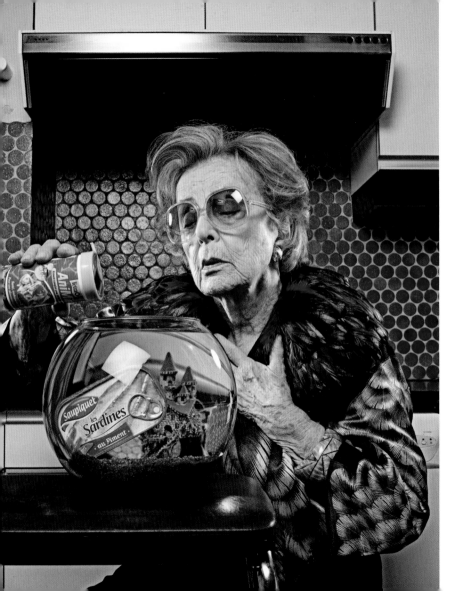

AMONG FISH TOO
THERE'S A
HOUSING CRISIS.

YOU SEE, WHAT'S REALLY
SHOCKING TO ME IS
THAT THE GLOVE IS NOT
THE SAME COLOR
AS THE SCARF.
WHAT LACK OF TASTE!

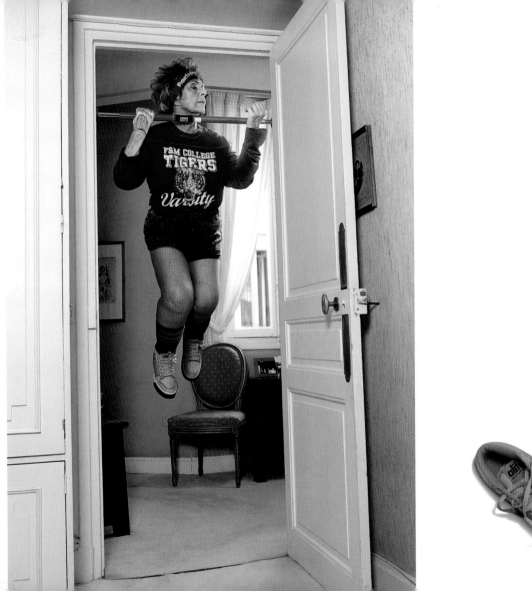

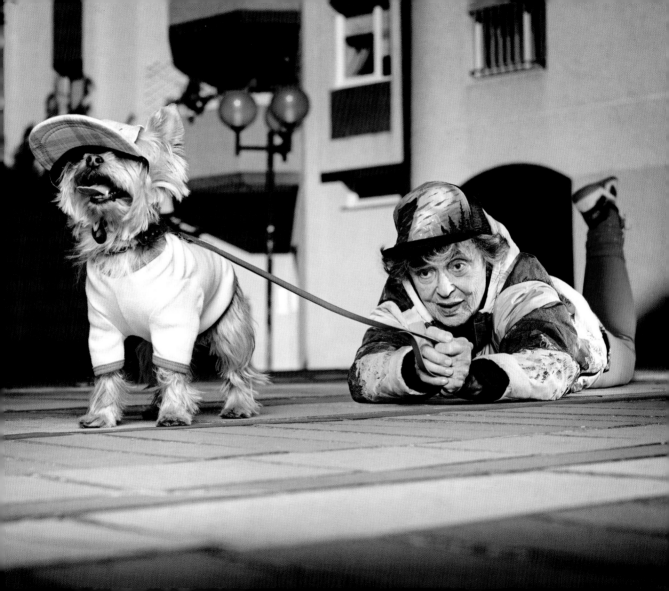

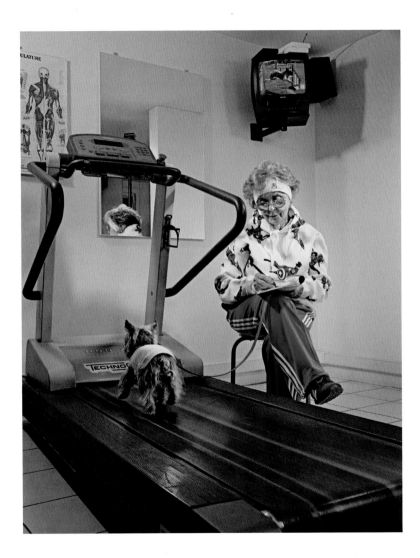

CAN'T YOU SEE?
WE'RE IN TRAINING FOR THE
NEW YORK MARATHON.

We took
this picture
at seven
in the
morning.
There is
no trick.
It was
amazing,
seeing her
like this,
**ALL ALONE
ON THE
PLACE
DE L'ÉTOILE,**
sitting
on an
exercise bike.
Never
could I have
imagined
being there
on a day
like this.

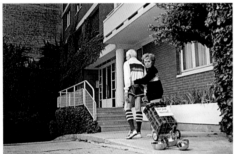

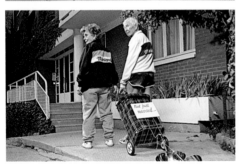

JUST SO YOU KNOW THE BACKSTORY,

the shoes we had picked for this picture hurt Mamika's feet. She whined so much that the stylist and I finally gave up. If you look at the picture closely enough, you will see that she's wearing a black-polka-dotted sock. She is; just look below the shopping cart...

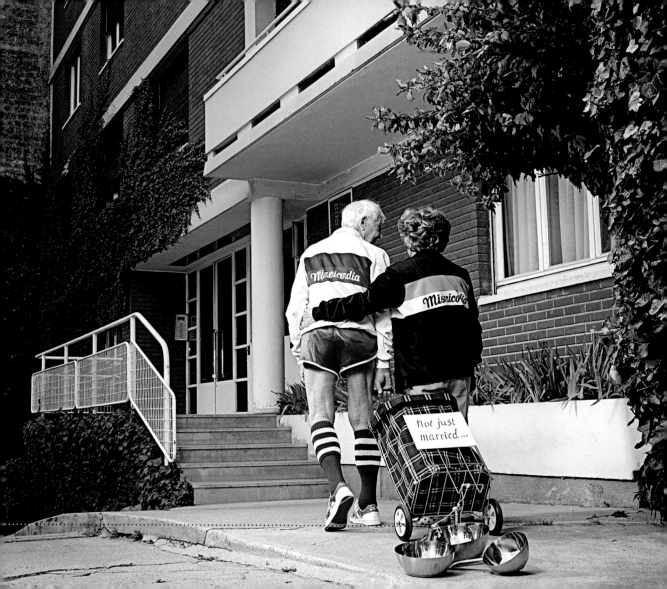

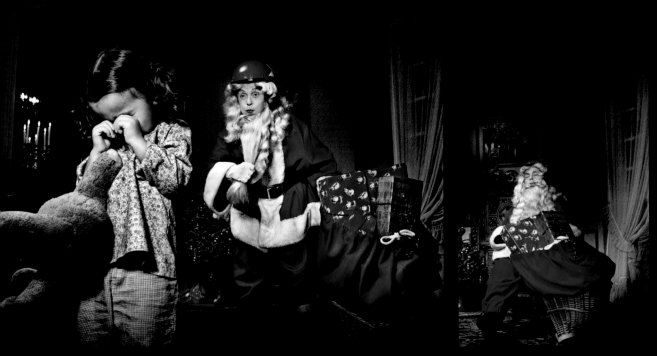

WHEN I WAS YOUNG, MY FATHER FORBADE ME TO GET MY EARS PIERCED.
HE DIDN'T WANT ME TO LOOK LIKE A **CHRISTMAS** TREE.

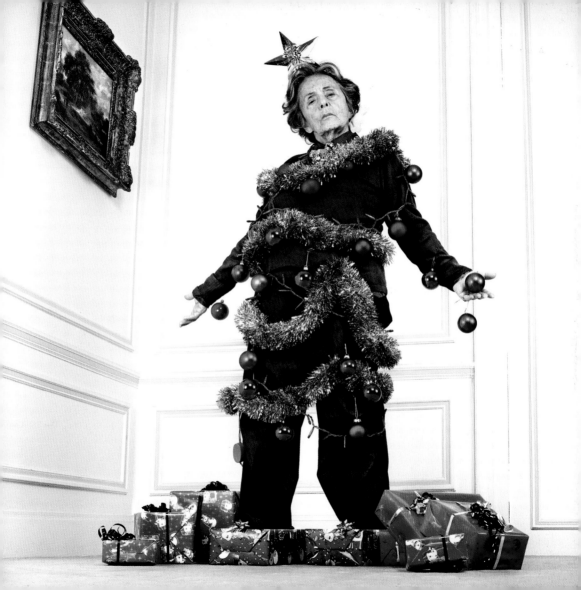

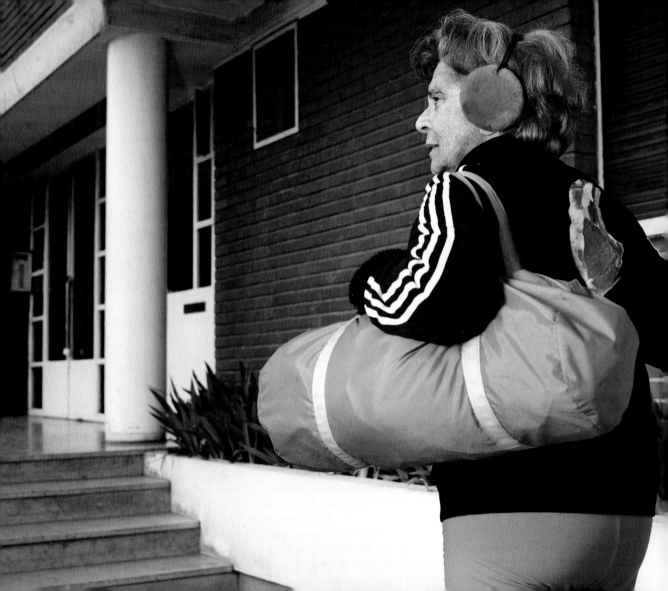

My initial plan was to shoot an April Fools' joke with a chicken. I called my grandmother the day before to make sure that nothing would happen to the defenseless chicken I had left at her house.

"You won't eat it, right? We're keeping it for tomorrow."

"Yes, Yes!"

she said in her touching accent.

The next morning, my grandmother came to the location with a half chicken. The model had eaten the prop—that was a first! Thanks to Mamika's appetite, the April Fools' chicken became an April Fools' pork chop.

THE CLOTHES DON'T MAKE THE

CHICKEN

(OR MAN).

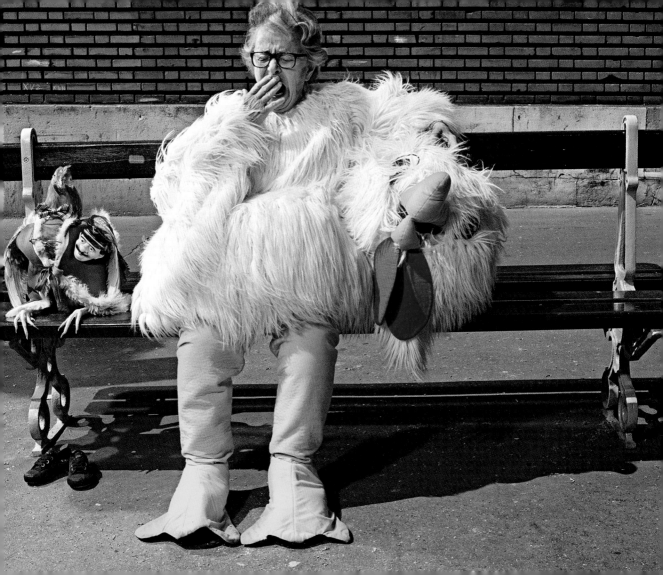

ONE OF **MAMIKA'S** JOKES:

FOUR JEWISH MOTHERS ARE PLAYING BRIDGE ON A SUNDAY AFTERNOON.

"OY OYYY, OYY!" GOES THE FIRST.

"OY OYYYY, OYY OYY OY!!!" GOES THE SECOND.

"OY OYYY, OYY OYYYYY OY!!" GOES THE THIRD.

"WE SAID WE WERE NOT GOING TO TALK ABOUT THE CHILDREN!" SAYS THE FOURTH.

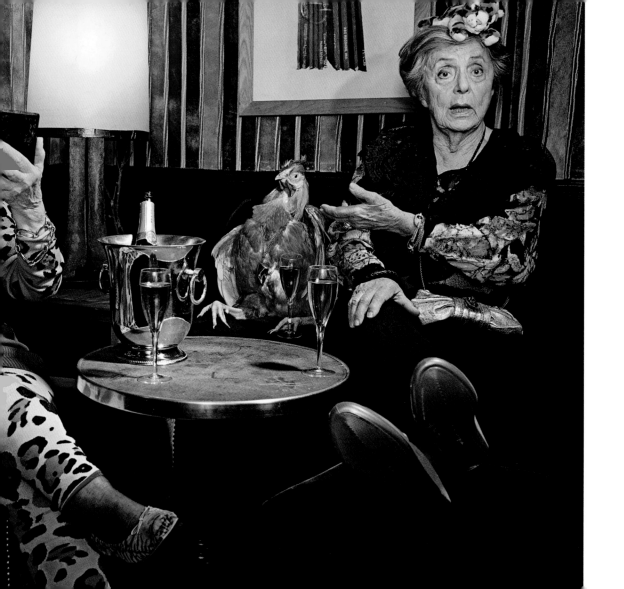

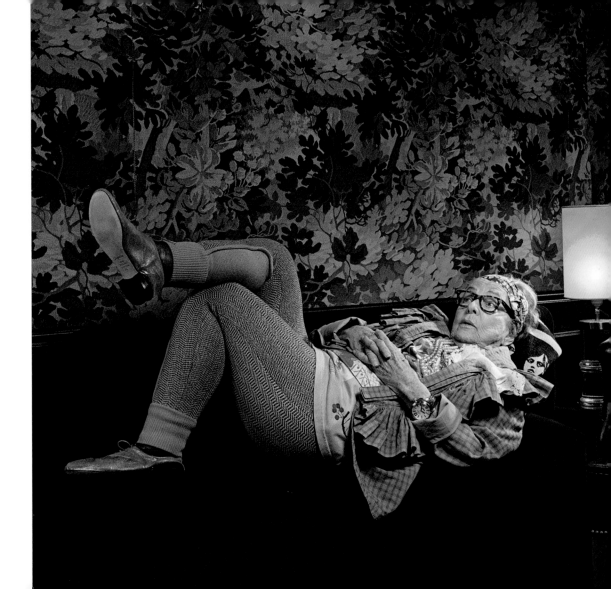

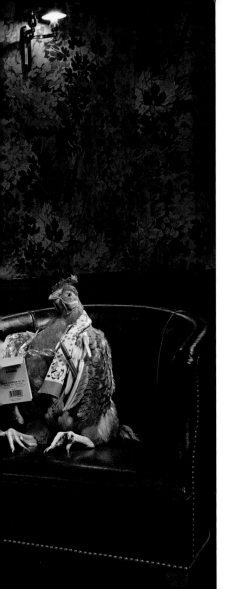

AS I REMEMBER IT, **FREUD** WAS A BIT TALLER.

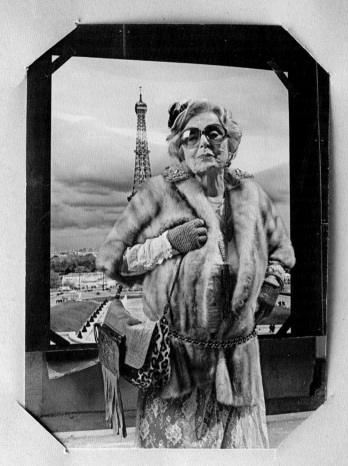

THIS LOOKS LIKE TOURISM **ON THE CHEAP.**

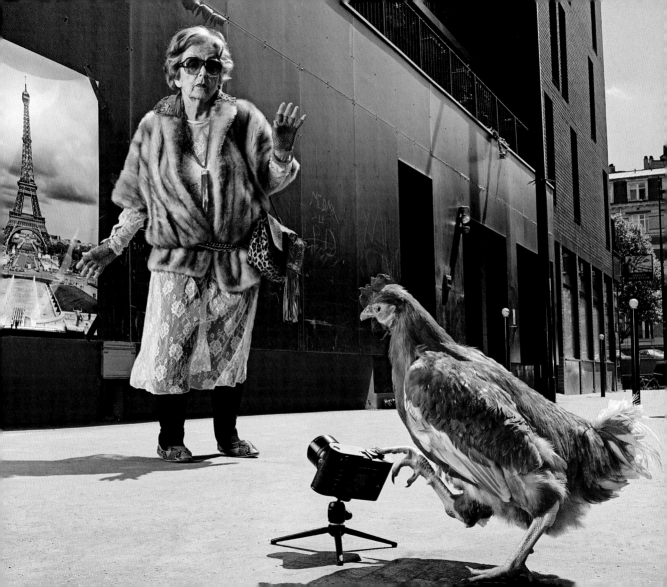

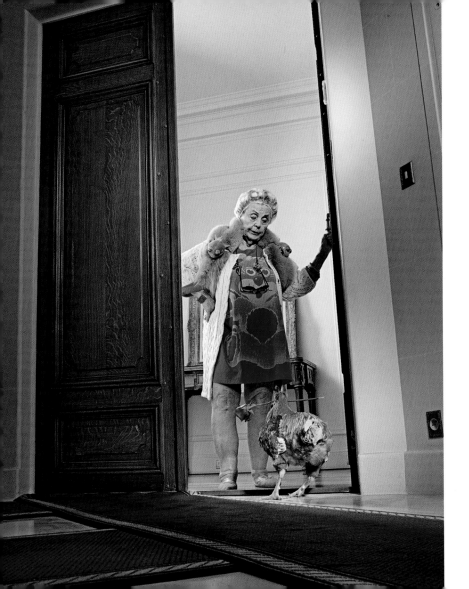

YOUR
GRANDFATHER
WAS
SHORT AND
BALD.
**THE PHYSICAL
ASPECT IS
NOT THAT
IMPORTANT,**
BUT STILL
THERE ARE
LIMITS
TO
EVERYTHING!
(Mamika
smiles.)

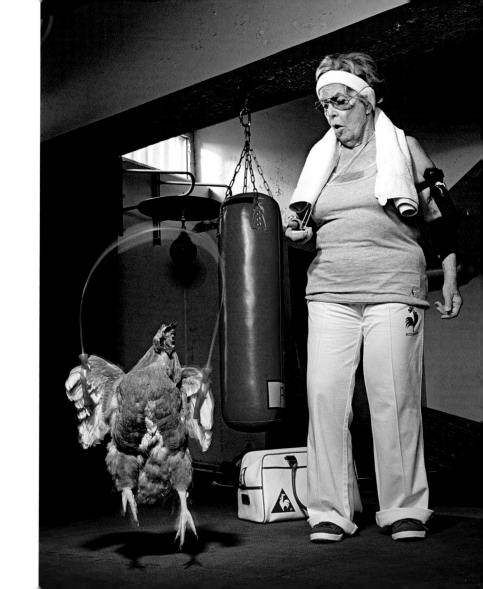

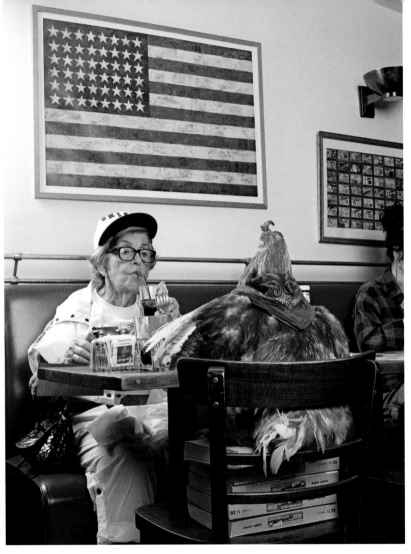

PEOPLE OFTEN UNDERESTIMATE HOW USEFUL THE **YELLOW PAGES** CAN BE.

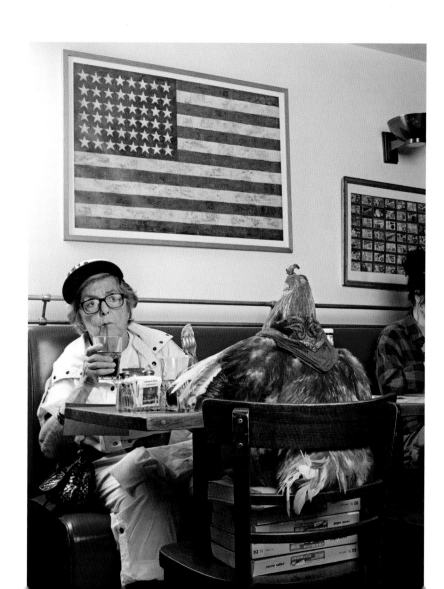

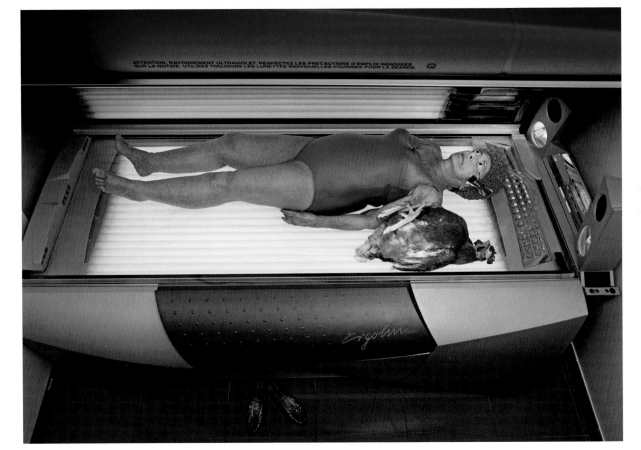

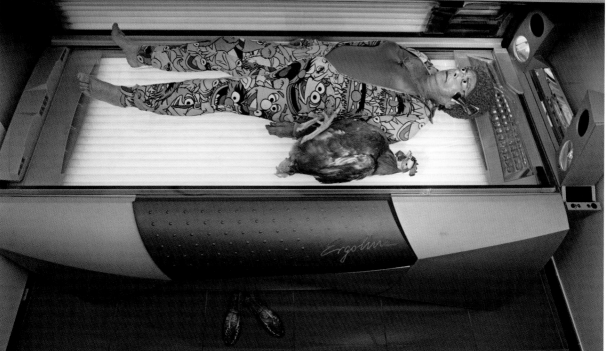

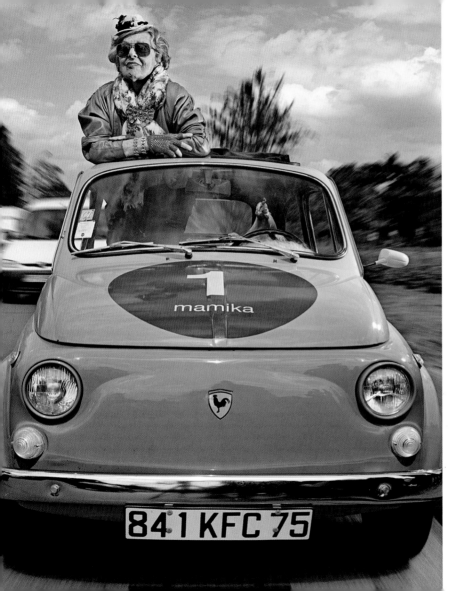

I AM NOT ABSOLUTELY CERTAIN THAT HIS LICENSE HAS BEEN RENEWED.

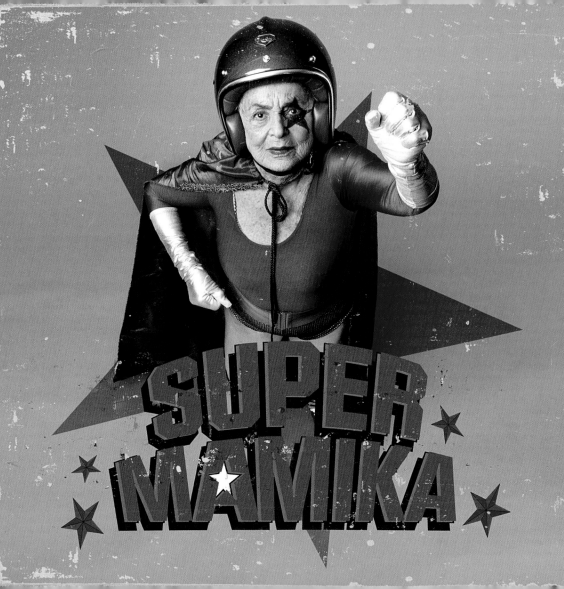

SUPER MAMIKA IS
WONDER WOMAN
AND SUPERMAN'S
GRANDMOTHER,
FULL OF SUPERPOWERS
BUT A LITTLE CLUMSY.

SHE
✪ DOES NOT CONTROL
HER OWN STRENGTH
✪ GETS INTO YOUR HOME
THROUGH A WINDOW
OR CRASHES INTO
THE WALL NEXT TO IT
✪ PREFERS TAKING A TAXI
TO FLYING
(BECAUSE IN A TAXI
AT LEAST YOU CAN CHAT)

FLYING WITH AN UNTIED SHOELACE IS DANGEROUS. YOU COULD SLIP.

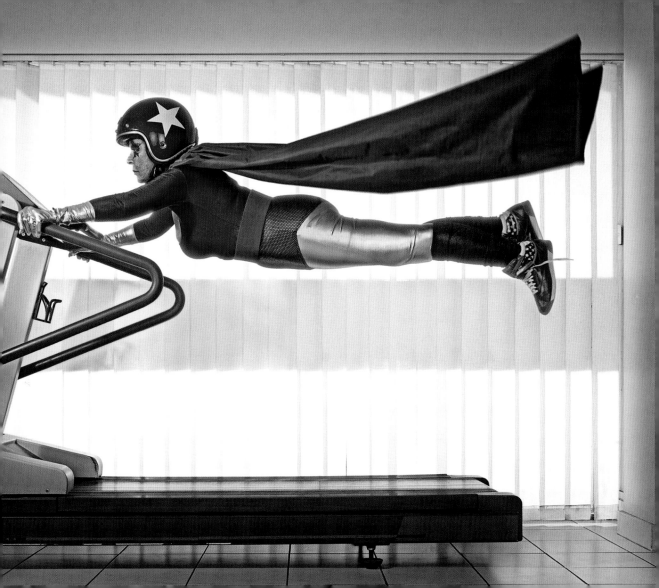

TAXI DRIVERS ARE SORT OF LIKE SHRINKS. THEY GET PAID TO LISTEN TO YOUR STORIES. AND ON TOP OF THAT, THEY DROP YOU OFF.

T

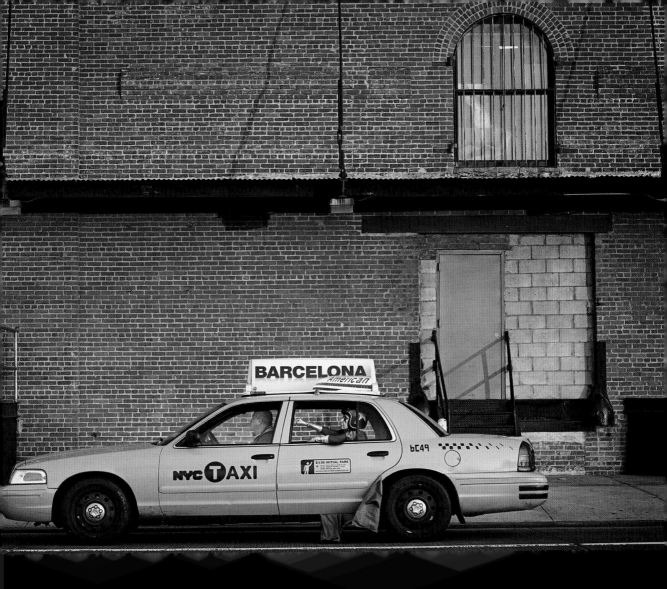

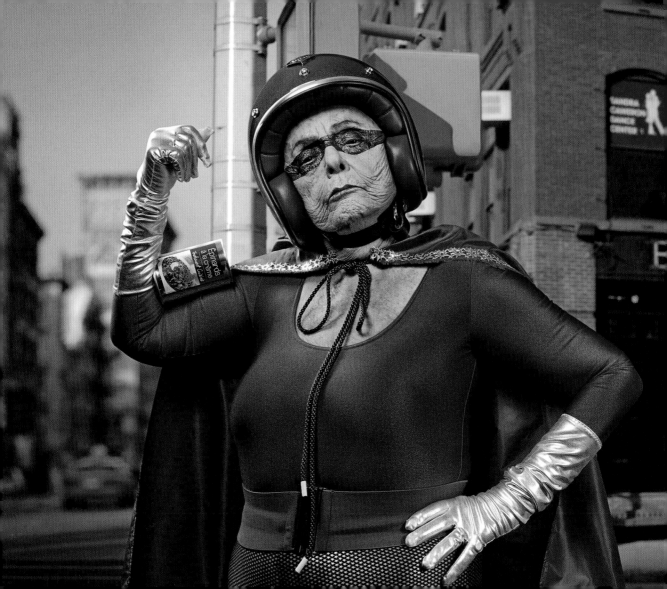

THE WAY I LIKE **spinach** BEST IS AS BICEPS.

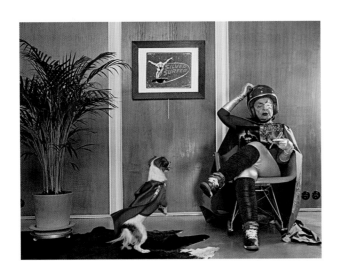

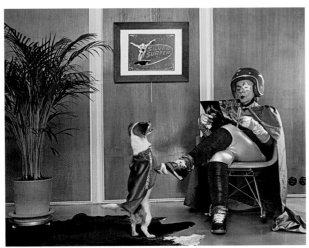

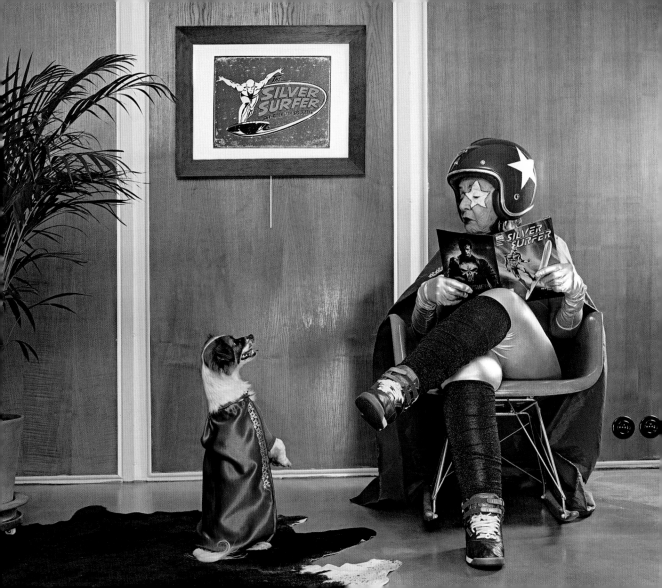

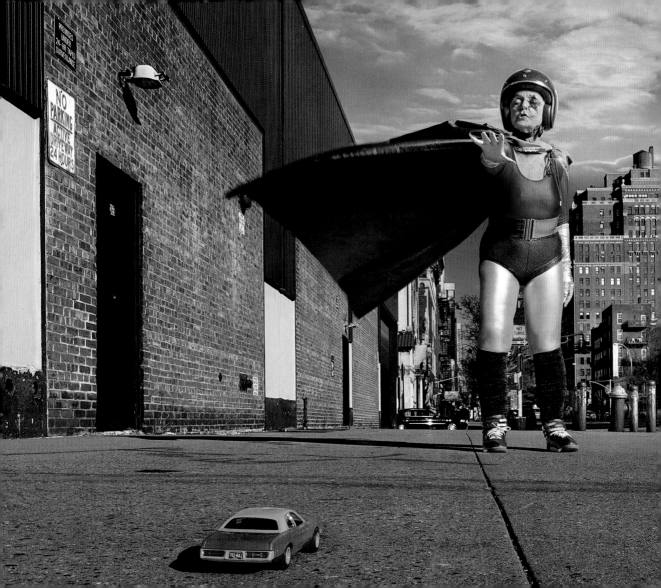

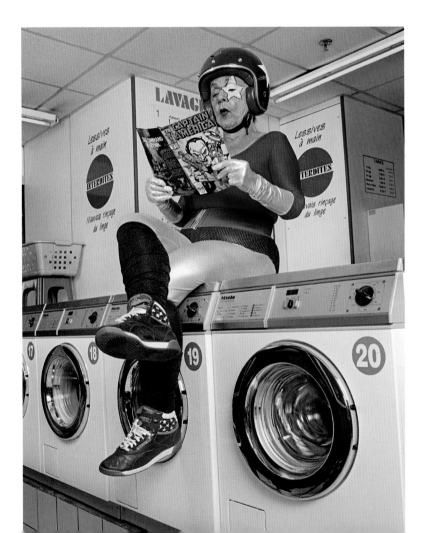

ON THAT DAY,
Super Mamika's powers
were on strike.
It took three of us
to get her up
onto the washing machine.

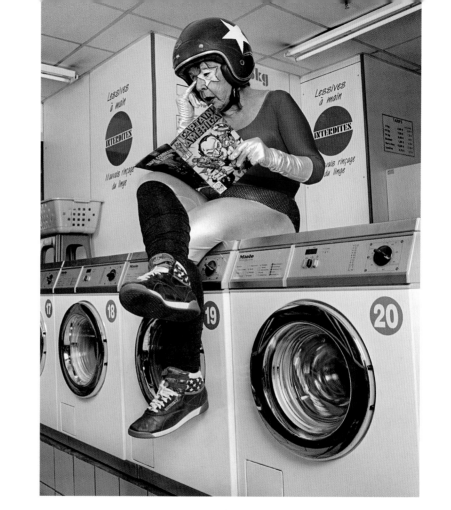

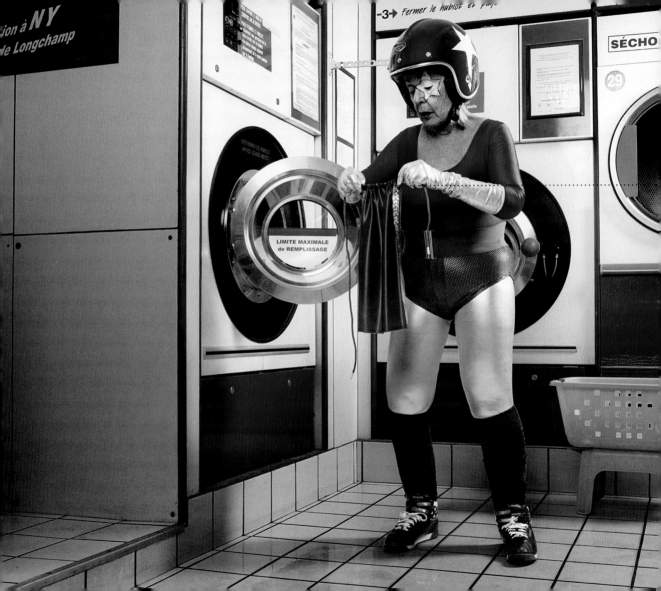

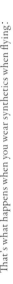

That's what happens when you wear synthetics when flying.

GUIDE ON HOW TO SHRINK A CAPE

Buy a superhero cape on sale. (Ask Wonder Woman for her sources: she's a bit of a cheapskate.)

Do not wear reading glasses. Set the dial on *hot/warm* rather than *cold/cold*.

Above all, do not follow label directions. Get the water boiling hot.

Soak the cape while whistling the *Batman* theme song.

Forget the cape while having tea with some Super Girlfriends who fill you in on Super Gossip about a potential affair between the Silver Surfer and Catwoman. Exclaim: "Super shoot, my cape!"

The cape is now ready. It has shrunk by half and has become completely useless.

The only thing you can do now is adopt a Super Dog.

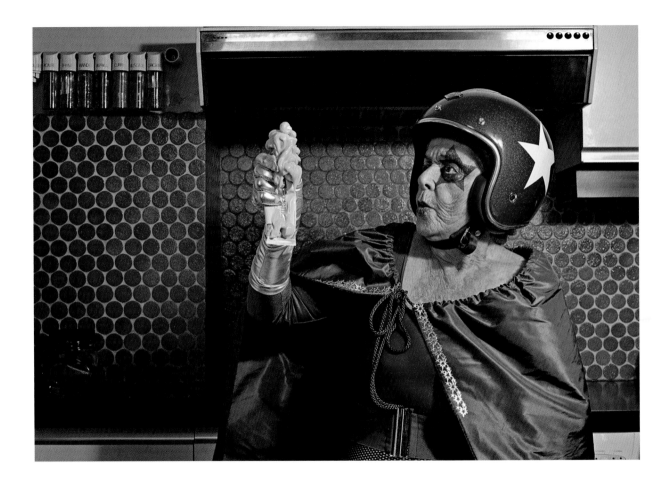

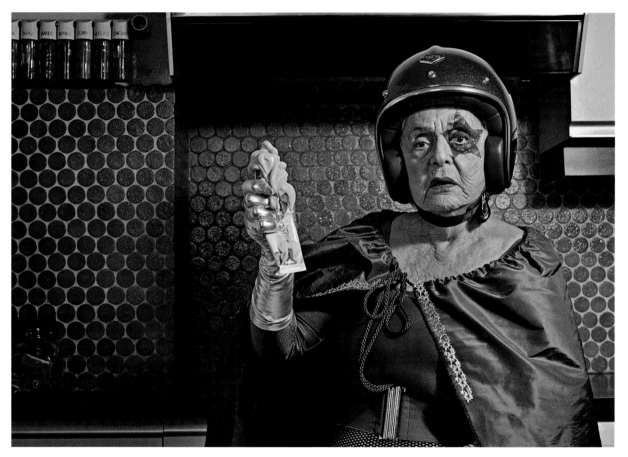

EITHER SUPER MAMIKA DOESN'T KNOW HOW STRONG SHE IS OR **THE MAYONNAISE** WAS IN A REAL HURRY TO COME OUT OF THAT TUBE.

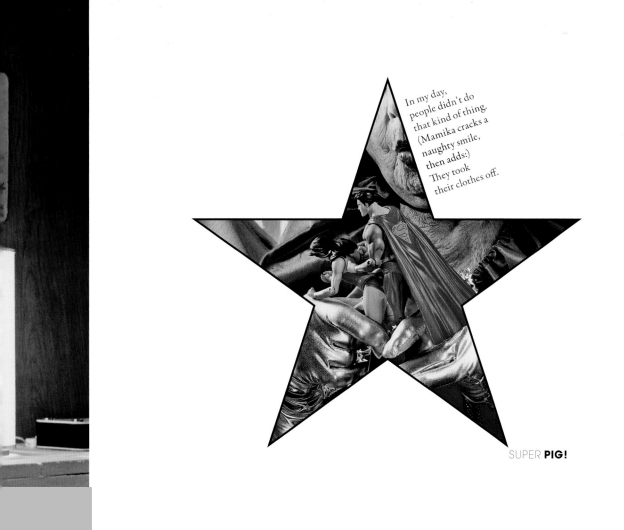

In my day,
people didn't do
that kind of thing.
(Mamika cracks a
naughty smile,
then adds:)
They took
their clothes off.

SUPER **PIG!**

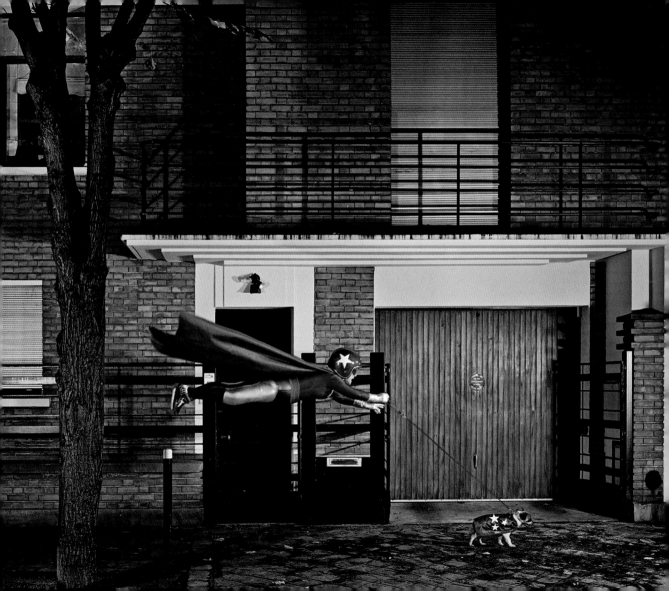

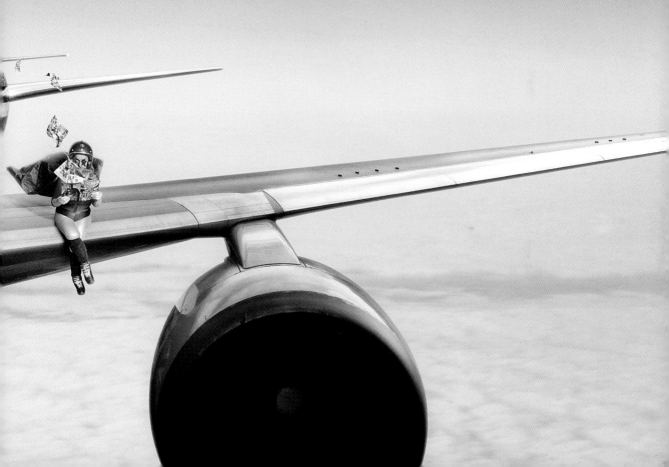

I WAS SITTING PEACEFULLY IN MY LIVING ROOM
WHEN YOU PHOTOGRAPHED ME,
AND NOW HERE I AM SITTING ON A PLANE . . . **YOU CON ARTIST.**

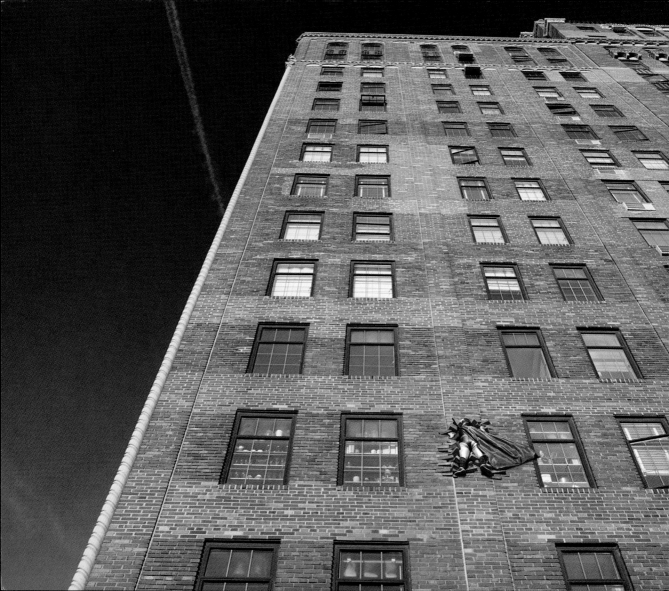

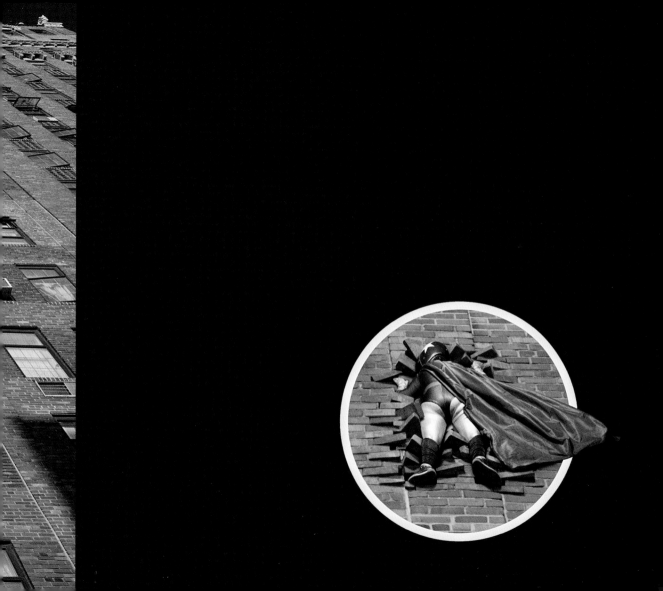

CANDY

NEW YORK
LOTTERY
GAMES

MOTT ST. N.Y.C. NY 10012

MIDDAY
119
9649
EVENING
461
0 590

HAVE a
TWO-
SOME

KRYPTONIC

WONDER DRINK

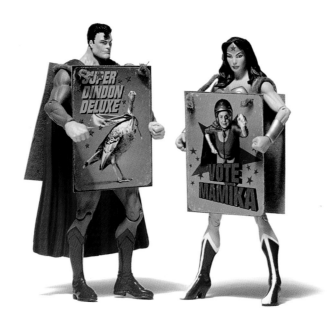

I'M NOT SURE I MAKE A VERY EDIBLE **SANDWICH.**

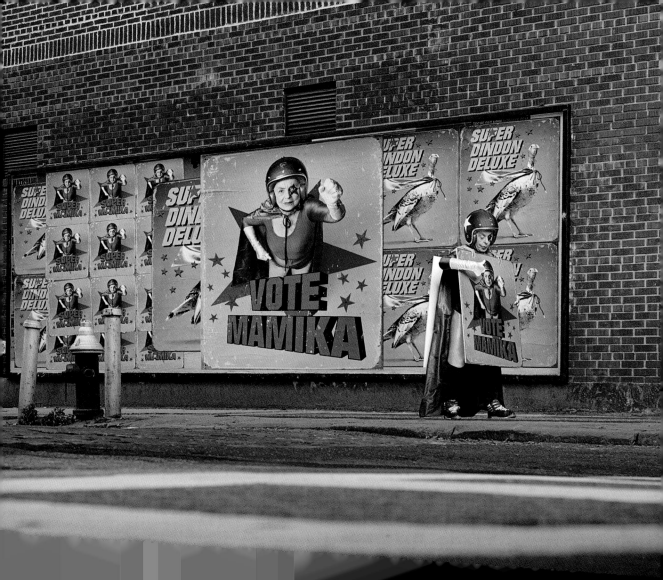

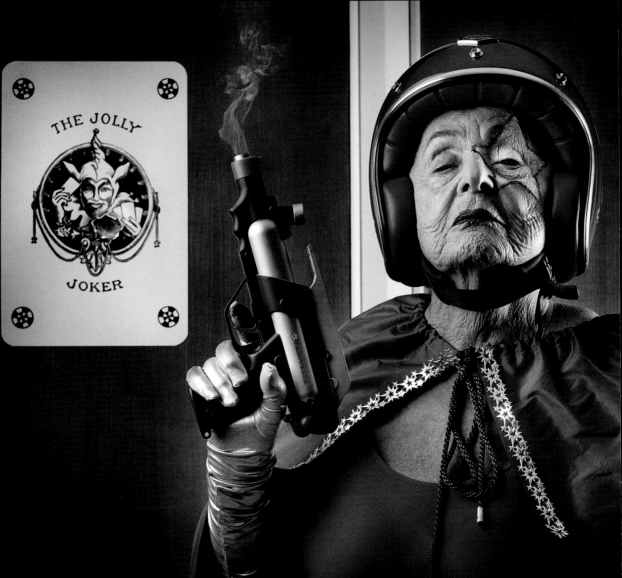

IF THIS PISTOL KEEPS ON **smokING** ...

IT'S GOING TO END UP WITH CANCER.

I HAVE NEVER SEEN SUCH AN AGGRESSIVE HOT DOG. IT TRIED TO BITE ME. FORTUNATELY, I WAS MUCH **HUNGRIER** THAN IT WAS.

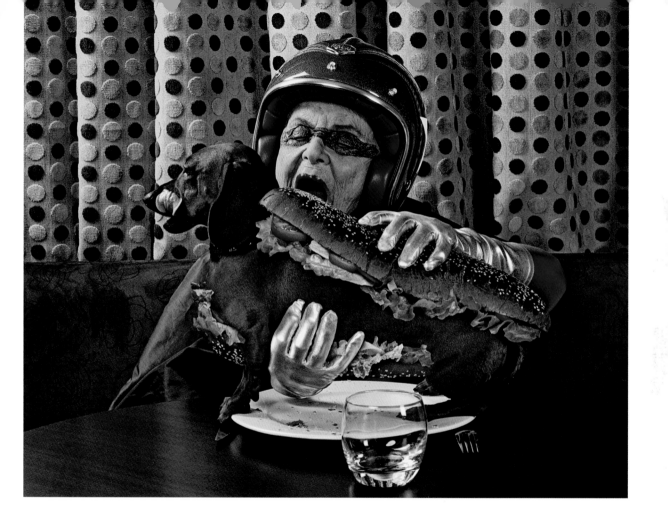

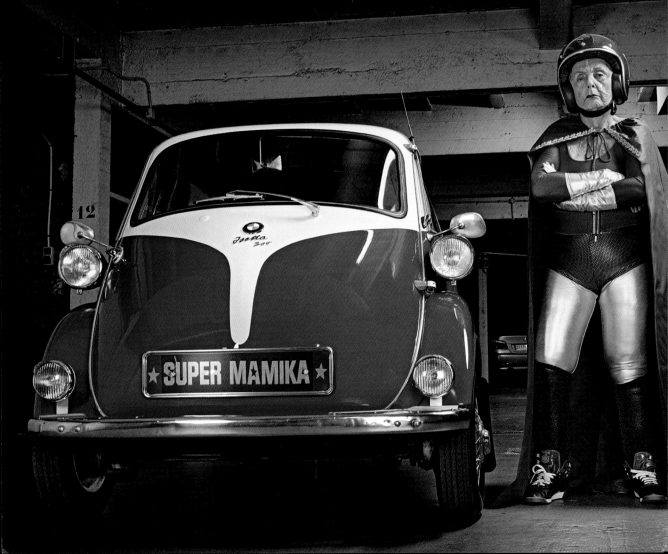

SOMETIMES CARS CAN GIVE VERY GOOD **face-lifts.**

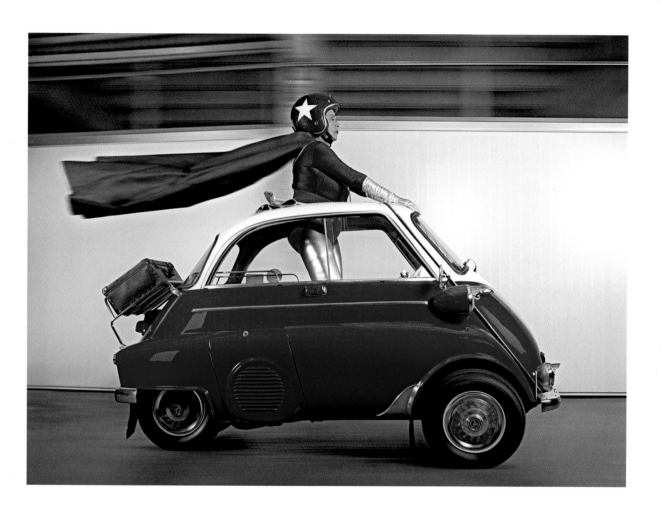

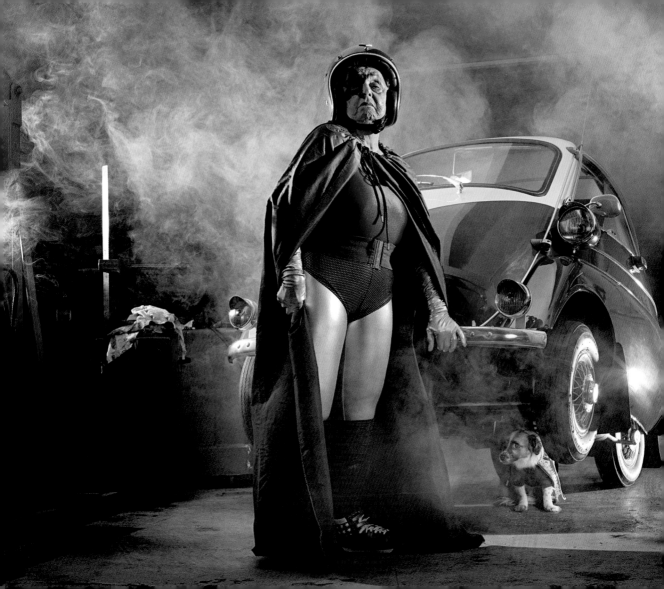

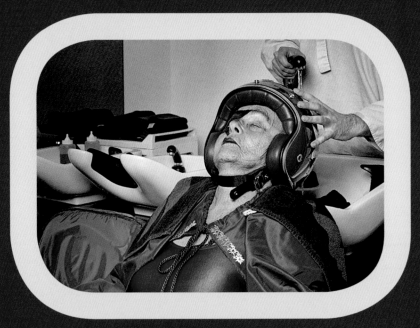

THE ADVANTAGE WITH SUPERHERO HELMETS
IS THAT THEY DON'T **FRIZZ**,
EVEN AFTER A WASH.

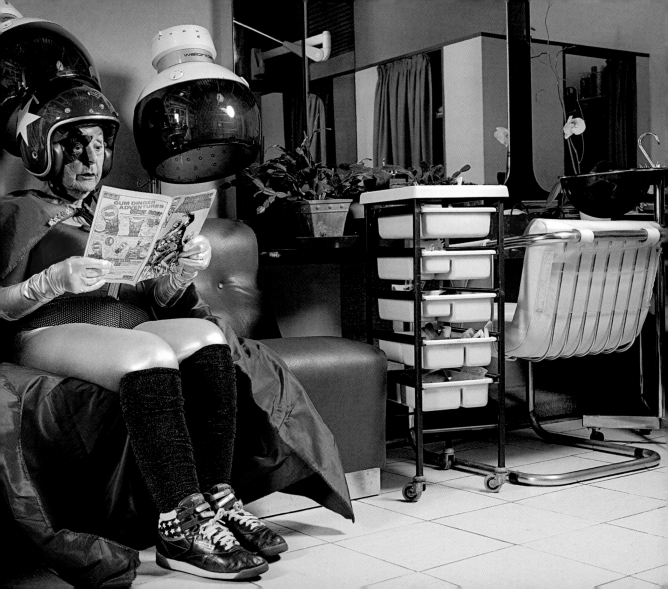

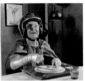
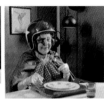
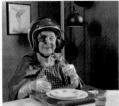
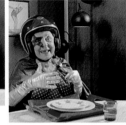

This was the biggest fit of hysterical laughter we had in the entire time we shot Mamika's pictures. My grandmother was in costume; everything was ready. I started taking photos; she wouldn't crack a smile. She was supposed to be looking straight ahead. I discreetly asked my assistant, Alexis, to make her smile. I don't know what went through his mind—he began a striptease. Throughout the shoot, Mamika tried to remain serious—that was impossible. The more she laughed, the crazier Alexis got. He ended up in his underwear. Mamika and the rest of the team were laughing to the point of tears. **"SACHA, TELL HIM SOMETHING; MAKE HIM STOP!"** my grandmother begged, laughing. While I was taking pictures, my own eyes were also full of tears from laughter; I must admit that I just couldn't see what I was shooting.

This is still making me laugh today.

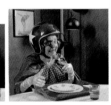
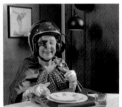
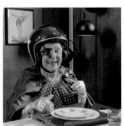
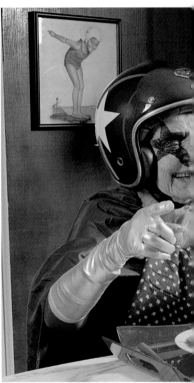

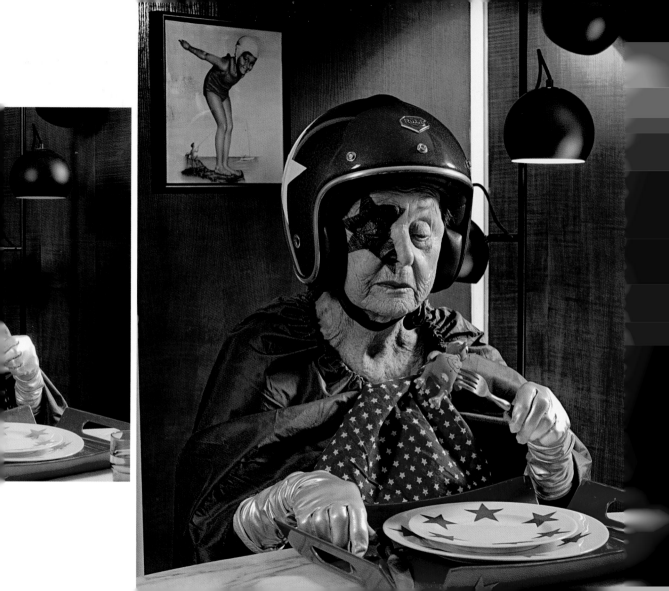

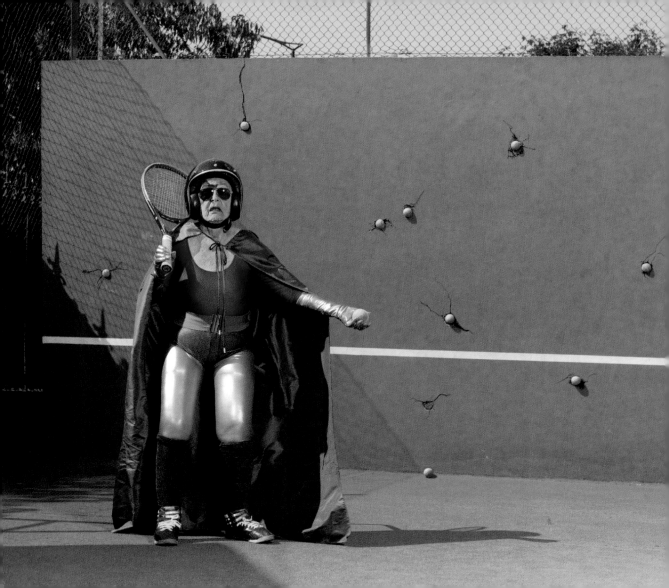

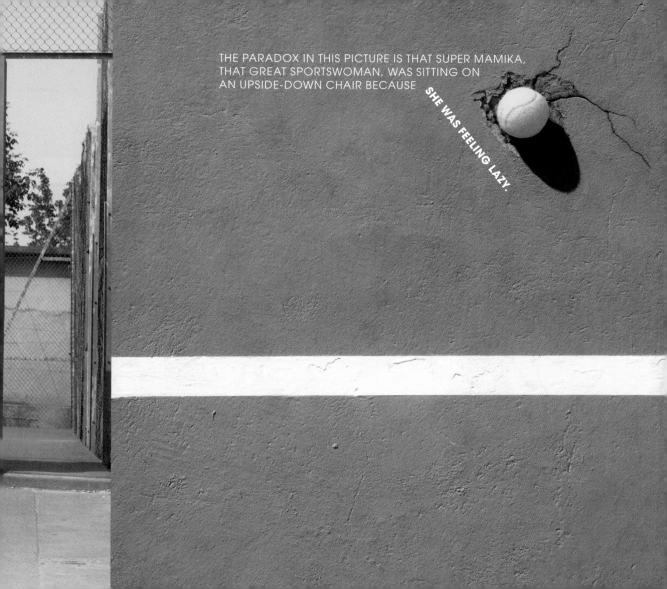

THE PARADOX IN THIS PICTURE IS THAT SUPER MAMIKA, THAT GREAT SPORTSWOMAN, WAS SITTING ON AN UPSIDE-DOWN CHAIR BECAUSE SHE WAS FEELING LAZY.

YOU SEE, MY DARLING, **SOME PEOPLE SMOKE AFTER SEX.**
I SMOKE WHEN I'M IN BED WITH A LITTLE PLASTIC DOLL...
I SMOKE OUT OF DESPAIR.

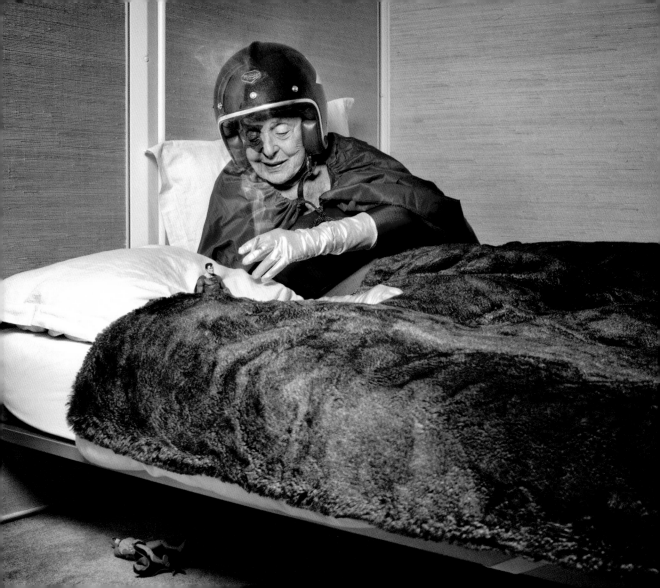

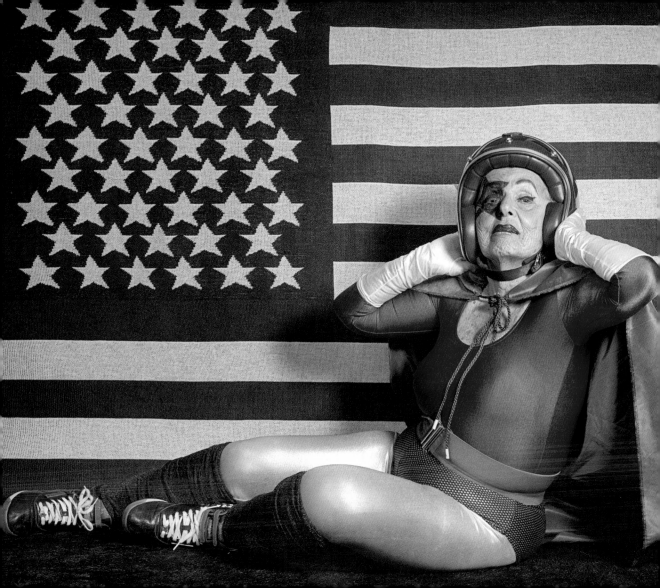

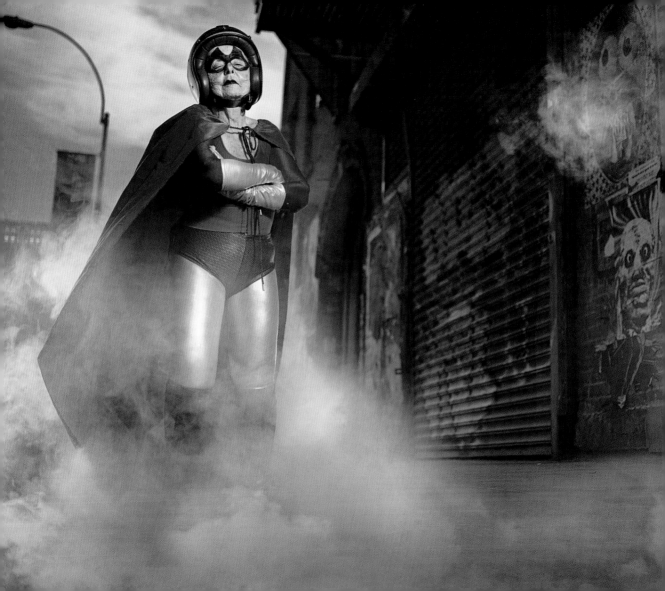

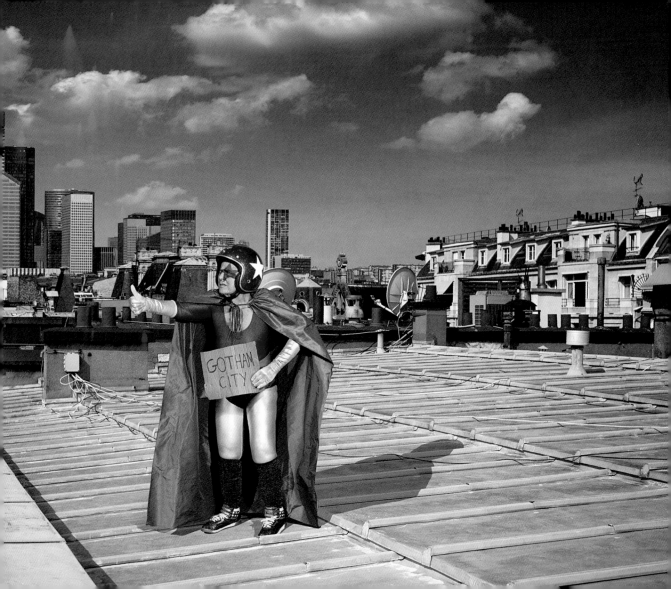

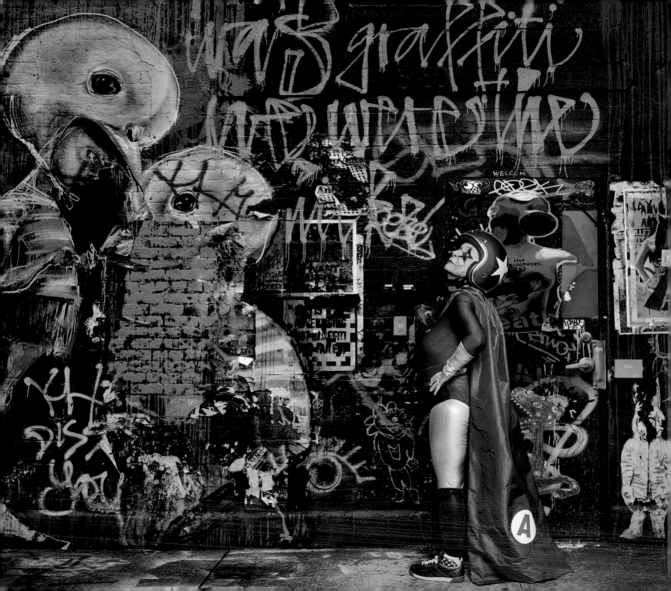

**AMONG SUPERHEROES,
THERE ARE STUDENT DRIVERS, TOO**
(EVEN SOME PRETTY ELDERLY ONES).

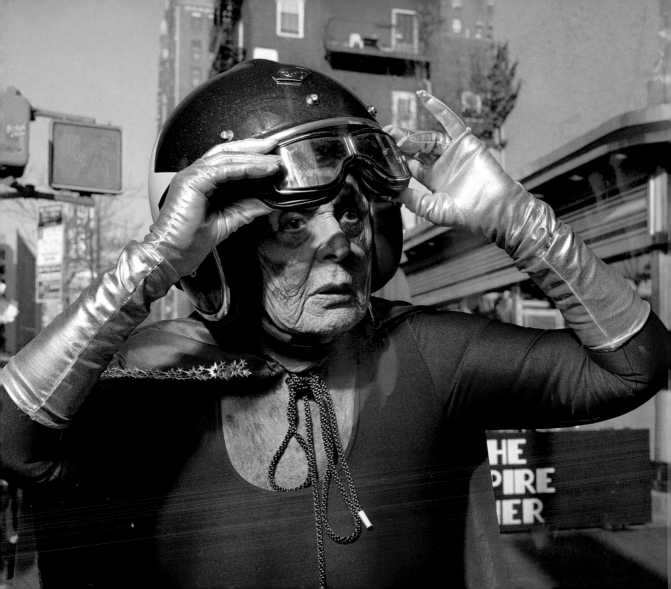

EMPIRE

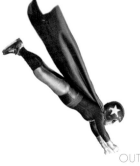

OUT LOOKING FOR **SUPER PAPIKA!**

THANK YOU

Thank you Marielle, Marielle, Marielle, Solène, Pali, Seb M., Julien, Alexis, Anaïs, Céline, Anina, Cécile, Monique L., David A., Jean-Claude, Hélène, Maya, Rémi, Christine, Margo, Claude Nature, La Salle, Cédric, Sonia, Harold, Justine, Laurence, Lionel P., David D., Catherine S., Gloria, Aminata, Gilles, Ilana, Emile, Coffee Parisien, Point Soleil, Julie, WAD, Brice, Marie, Bruno, Véronique B., Alexis, Seb P., Charlotte, Justine, Sarah, Gilles, the gherkin that was willing to act, Seb M., Marie, Séverine, Christophe R., Michael, Jasmine, Deborah, Chiara, Chloé, Laurent, Kitty, Wladi, Jérome, Céline, Jean-Etienne, Ruby, Laura, Patricia, Reebok, Harmonie Coiffure, Lionel 19, Cerise, Joel and Louisette, Carole, Maxime, Maya, Saucisse, Sophie and Fred, Batman, Superman, Tennis Club de Boulogne Billancourt, Michel and Carole, Olivier, Jean Louis, Jean, David and Magali, Saratatouille, Mom, Bob the Chicken, the XXXXXXL pair of underwear, my ben, Aude, Angélique, Isaora, and especially, Mamika, who has the patience of an angel.

MAMIKA IS AN ANGEL
LEOTARD, PETTICOAT, AND BALLET SHOES: **REPETTO**; GLOVES: **AGNELLE**; WATCH: **CHEZ MAMAN (4, RUE TIQUETONNE, PARIS).**

MAMIKA DRESSES UP AS A CHICKEN
BOB THE CHICKEN: SLEEVELESS CARDIGAN: **LOUIS LOUISE**; T-SHIRT: **MAX & LOLA**; BOW TIE: **KILIWATCH**; GLASSES: **LULU BABY**; SHOES: **FEIYUE.**

MAMIKA LIKES A PARTY WITH CHA-CHA
MAMIKA, RIGHT: CARDIGAN, BELT, AND LEGGINGS: **KILIWATCH**; SHOES: **MELISSA BY VIVIENNE WESTWOOD**; HAT: **JEAN-CHARLES DE CASTELBAJAC**; HANDBAG: **VELVETINE**; NECKLACE AND RING: **SCOOTER**; BRACELET ON RIGHT WRIST: **KMO JEWEL**; BRACELET ON LEFT WRIST: **MOUTON COLLET.** MAMIKA, LEFT: SWEATER, NECKLACE, AND LEGGINGS: **JEAN-CHARLES DE CASTELBAJAC**; BALLET FLATS: **BLOCH**; BELT: **KILIWATCH**; BRACELET: **SCOOTER.** ON BOB THE CHICKEN: BRACELET: **MOUTON COLLET.**

MAMIKA TELLS HER SHRINK HER PROBLEMS
MAMIKA: CARDIGAN: **ROZALB DE MURA**; T-SHIRT: **YVONNE**; LEGGINGS: **TOUCH LUXE**; SHOES: **REPETTO**; HEADBAND: **MIKAELLA ASSOULINE**; GLASSES: **RAY-BAN**; NECKLACE: **FORTE FORTE**; BOW PIN: **LES NÉRÉIDES**; WATCH: **TW STEEL**; PILLOW: **DÉVASTÉE.** ON BOB THE CHICKEN: SCARF: **COQ EN PÂTE**; GLASSES: **BABY LULU**; WRITING PAD: **RHODIA.**

MAMIKA IMMORTALIZES HER VISIT TO PARIS
FUR: **KILIWATCH**; DRESS, COLLAR, AND BELT: **ROOM SERVICE (52, RUE D'ARGOUT, PARIS)**; SHOES: **LES PRAIRIES DE PARIS**; SUNGLASSES: **MIU MIU**; NECKLACE: **HÉLÈNE ZUBELDIA**; BRACELETS: **KMO JEWEL** AND SCOOTER; GLOVES: **MAISON FABRE**; HANDBAG: **JÉRÔME DREYFUSS**; HAT: **MURMURE BY SPIRIT.**

MAMIKA LOVES ROSES
FUR: **BLANCS MANTEAUX**; KERMIT NECKERCHIEF: **JEAN-CHARLES DE CASTELBAJAC**; VEST: **IVANAHELSINKI**; T-SHIRT: **VIVIENNE WESTWOOD**; BALLET FLATS: **REPETTO**; EYEGLASS NECKLACE: **JEN MOOD**; BRACELETS: **KMO JEWEL.**

MAMIKA PRACTICES SPORTS
TANK TOP, SWEATPANTS, AND BAG: **LE COQ SPORTIF**; SNEAKERS: **FEIYUE**; HEADBAND AND GLASSES: **KILIWATCH**; WATCH NECKLACE: **ODM**; ARM-GUARD: **PUMA.**

MAMIKA LIKES AMERICANS AND DRINKS DIET COKE
JUMPSUIT, T-SHIRT, GLASSES, AND BANDANNA: **KILIWATCH**; CAP: **NEW ERA**; HANDBAG: **JÉRÔME DREYFUSS.**

MAMIKA SUNBATHES WITH BOB
JUMPSUIT: **JEAN-CHARLES DE CASTELBAJAC**; SWIMSUIT, HAT, AND SHOES: **KILIWATCH**; BOW BARRETTE: **LES NÉRÉIDES.**

MAMIKA GOES FOR A SPIN IN THE FIAT
CARDIGAN: **KILIWATCH**; SCARF: **ÉPICE**; BOW PIN: **MANOUSH**; HAT: **MURMURE BY SPIRIT**; GLASSES: **TOPSHOP**; BRACELETS: **CAROLINE BAGGI**; GLOVES: **MAISON FABRE.**

MAMIKA AS SUPERHERO
RED LEOTARD: **REPETTO**; UNDERWEAR, BELT, AND LEGGINGS: **AMERICAN APPAREL**; WONDER WOMAN SNEAKERS: **REEBOK**; HELMET: **RUBY.**

NO VIBRATOR WAS HARMED DURING THE SHOOTS.

And thanks to the press offices of American Apparel, Catherine Miran, Chez Maman, Cosi Com, Jean-Charles de Castelbajac, Kidding, Kiliwatch, L'Appart, Morozzo, Poulain & Proust, Presslab, Pressmixer, Puma, QG, Reebok, Room Service, Vivienne Westwood, Studio 3ème Droite.

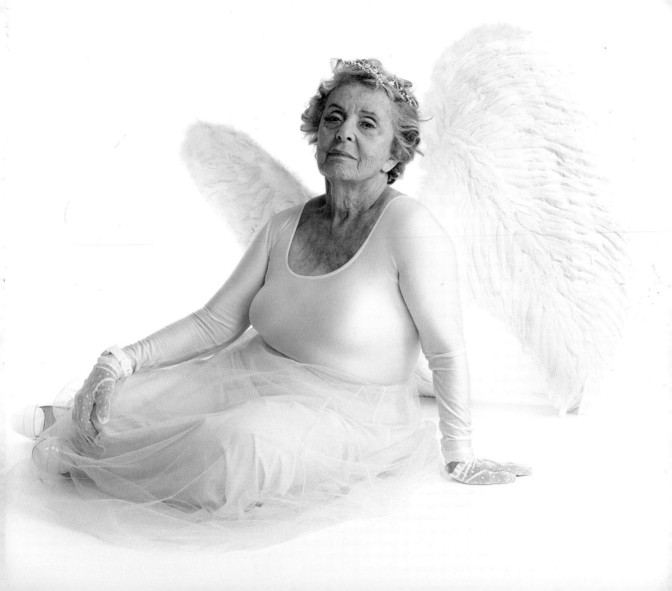

Graphic conversion: ben@bensimon.fr